CEIJA STOJKA

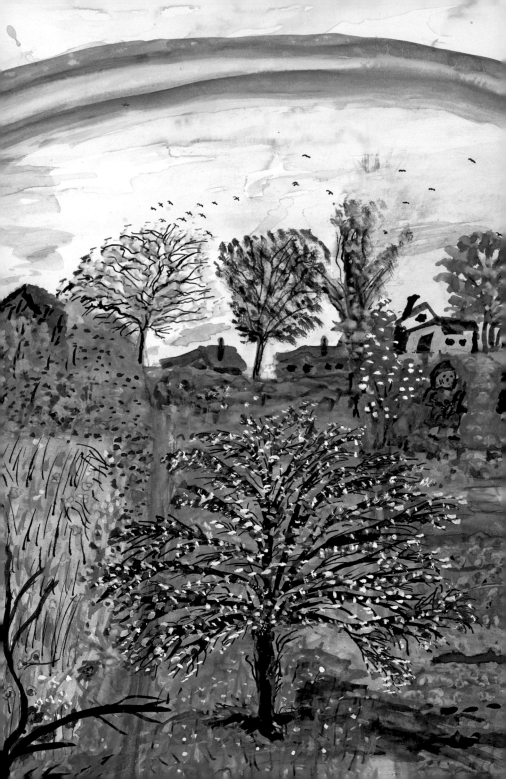

Roma Artist

CEIJA STOJKA

What Should I Be
Afraid of?

HIRMER

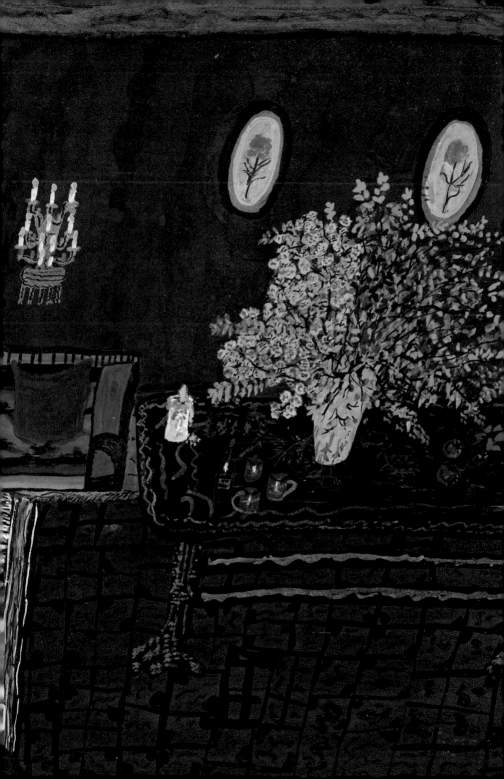

CONTENTS

PREFACE

The Austrian Cultural Forum New York dedicates this volume to a truly remarkable woman: Ceija Stojka. She was a survivor of three concentration camps, self-taught artist, courageous activist, dedicated mother, grandmother, matriarch–and a moral compass for many.

Ceija would have blown out her 90 birthday candles on May 23, 2023, the day of the opening of the exhibition "What Should I Be Afraid of? Roma Artist Ceija Stojka" at the ACFNY. Family members, friends of Ceija, and art lovers from New York and the USA as well as visitors from abroad, celebrated her comprehensive artistic legacy by exploring 90 original works of art, her poems, her biography, and her stories, as well as her music at this occasion and in ensuing film presentations, concerts, and performances that accompanied the exhibition until late September 2023.

With this project, the ACFNY also highlighted the fact that the Roma and Sinti received the legal status of an ethnic group in Austria in 1993, an important political decision that recognizes the specific culture and language of the Roma in our country and consolidates the memory of the horrific losses and atrocities they had to endure under the Nazi regime.

In 2023 the Austrian Foreign Ministry celebrated the jubilee of 50 years of Austrian cultural diplomacy, a solid pillar of our foreign policy. Against the backdrop of multidimensional global crises that challenge human existence, the call for the protection of human dignity is a leading topic for our cultural work. Ceija Stojka, who suffered unspeakable humiliations and trauma during her childhood and as a young woman, managed–against all odds–to nourish her emotional strength, her boundless creativity and her "joie de vivre." She stood up for her rights in the most dignified way and thus serves as a role-model for future generations.

Fig. 1: Ceija Stojka, *Untitled*, 2006

I thank the curators of the exhibition, Stephanie Buhmann, Lorely French, and Carina Kurta for their dedicated work which made this very special project a success both in New York and through this publication. I thank the members of the Stojka family, our sponsors, lenders, friends, the team of the ACFNY, and many helpful partners for their invaluable support. I would also like to thank Simona Anozie and Michaela Grobbel for contributing their insightful texts. Let us keep the memory of Ceija Stojka alive!

Susanne Keppler-Schlesinger
Director
Austrian Cultural Forum New York

ACKNOWLEDGEMENTS

This publication has been made possible through the invaluable support of different entities. We would like to thank the Austrian Cultural Forum New York, Kontakt Collection; National Fund of the Republic of Austria for Victims of National Socialism; Future Fund of the Republic of Austria; Galerie Christophe Gaillard, Paris; Pacific University Elise Elliott Undergraduate Experience Enrichment Fund; Sonoma State University, and Sonoma State University's Center for the Study of the Holocaust & Genocide.

Before the book, the exhibition *What Should I Be Afraid of? Roma Artist Ceija Stojka*, curated by Lorely French, Carina Kurta, and Stephanie Buhmann, was hosted by the Austrian Cultural Forum New York in cooperation with the Ceija Stojka International Association. The lenders to this project included private collections, as well as Galerie Christophe Gaillard, Paris; Estate Family Stojka, Vienna; Pacific University, and Stackpole & French Law Offices, Stowe, Vermont. We would like to express our sincere gratitude to all of them.

In addition, we would like to thank the Austrian Embassy Paris, the Austrian Cultural Forum Paris, Foksal Gallery Foundation, Geoffrey Howes, Kallir Research Institute, New York, and Alexandra Reill for her editorial assistance with Simona Anozie's essay.

Most importantly, we would like to thank Ceija Stojka's extended family for entrusting us with presenting Ceija Stojka's work to a new audience and exploring her legacy, especially Hojda, Nuna, Pablo and Harri Stojka, as well as Simona Anozie.

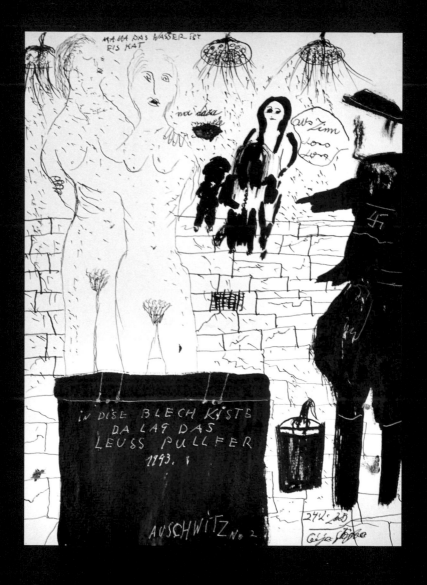

Fig. 2: Ceija Stojka, *Mama, the Water is Freezing. 1943 Auschwitz*, 2005

I KNOW THAT A TREE IN THIS PLACE IS NOT LIKE ANY OTHER

MY GRANDMOTHER

BY SIMONA ANOZIE

As a child my grandmother loved horse trading and selling rugs, riding to the markets, life in the wagon, and traveling over the country roads in Austria. She knew the map by heart, better than any GPS, and later in life she was a very good driver. When I was riding with her, she showed me the places where the families had stationed their wagons.

Every time she returned from visiting another country, she was always happy to be home again: "I am a root from Austria." When she was in Japan to give a lecture, she ate only potatoes; anything else felt too unsafe for her. Ceija Stojka loved Austria, despite the dark times she had to experience. Once I asked her: "Why did you all stay here?" That wasn't even a question for her. She would not have felt comfortable in another country–"a root that is also not to be transplanted."

Her fears and nightmares, my grandmother did not like to reveal. But from time to time, they broke through, whether she wanted them to or not. Sometimes, when we were cooking and my mother Silvi peeled the potatoes too thickly, she would say: "With this peel... I would have had two days of food..., in Auschwitz." Or–I was looking

to buy a car. At the used-car dealer we saw an SUV, but because it had a sticker with an eagle on the side, she right away refused to let me buy this car. She also did not like any tattoos because of her concentration camp number. I always knew that what she had experienced as a child had not only been really dark. It was pure horror. We did not have to talk much…

I was even more proud when she had written her first book: *Wir leben im Verborgenen. Erinnerungen einer Rom-Zigeunerin* (*We Live in Secrecy. Memories of a Romni-Gypsy*) in which she describes the terror that she and our family were exposed to in the concentration camps. As the first autochthonous Lovara woman she had told her story in the 1980s, thereby breaking with the traditions and the patriarchal Roma community. As a woman you do not simply go out into the world. Besides, you do not talk with "Gadje"[1] about "Roma affairs." Romany was still kept secret; being a Rom or Romni[2] was hidden. Concentration camp victims kept silent about their survival.

She had conquered her fears. She had broken her silence, and from this moment on she turned to the world, gave talks against forgetting, and went into schools to recount what she had experienced. She received numerous awards for her work as a witness.

And she kept writing. *Reisende auf dieser Welt* (*Travelers in this World*) looks at her life after the war and the hardship to rebuild a "normal" life. In *Träume ich, dass ich lebe?* (*Am I Dreaming I'm Alive?*) she remembers the atrocities of the Bergen-Belsen concentration camp and the liberation by the British army. Then, in 2008, *auschwitz ist mein mantel* (*auschwitz is my overcoat*) appeared with poems and pictures.

Besides writing, painting was her passion and another way to vent the torments that needed to be expressed. After her first book, she had thought she had broken through the wall of her fears, but again and again, she was forced to fight with them. She had to bring the horrors out in words on paper and in pictures on canvas. She had to live through it again and again, when she wanted to be sure that she would never experience it again.

Wir sind nicht traurig
Dass wir tot in Bergen-Belsen
Durch Hunger Durst
und Prügel bezwungen
Der Tod ist Die Erlösung
So schön Wie Die Geburt
Doch sollen die Massengräber
drohend sich erheben
Ein Riesenvogel
und zu denen schweben
die an ihrem Tode Schuld sind
in ihren Gedanken ruhelos leben
Massengräber da und dort
Bin ich schuldig
Der Menschenvogel zieht an mir vorbei
Hab ich Glück
ich war nicht dabei

We are not sad
that we dead in Bergen-Belsen
subjugated by hunger thirst
and floggings
Death is the redemption
As beautiful as birth
But should the mass graves
rise up threateningly
One giant bird
and soar over to those
who are guilty of the deaths
live on restlessly in their thoughts
Mass graves here and there
Am I guilty
The bird made of humans passes by me
I am lucky
I was not among them[i]

After Auschwitz-Birkenau and Ravensbrück, the Bergen-Belsen concentration camp was where she was at the end. On the occasion of the 45th anniversary of the liberation, she was invited to the memorial site. She drove her car the entire long way, my aunt Nuna in the passenger seat, and I in the back. We spent the night at a rest stop. A double bed stood in the room; a fold-out Murphy bed was mounted to the wall. Right away she said to me: "You are not sleeping there. You are going to sleep with us." The Murphy bed reminded her far too much of the wooden bunks in the barracks.

The next day we drove on. It was obvious that her fears were creeping up more and more with every kilometer we drove. Shortly before we arrived, my grandmother immediately recognized the tall, dark conifers that stood along the road. The sunny light of the day disappeared, the shadows of the trees made everything dark... There was no air to breathe there... The journey through the forest seemed endless... That is when I realized how hidden the place was... And then, all of a sudden, there was the huge area where the concentration camp had stood.

On the vast grounds of Bergen-Belsen Ceija searched for "her" barracks. Where in 1945 the corpses had been piled up in front of the shacks, today there are the mass graves, on each of the mounds a sign: 3,000, 4,000, 5,000 dead... The barracks are demolished and burned down; but my grandmother found the place where "hers" had stood.

And she found her "tree of life"—the tree whose leaves and bark she had chewed, whose resin she had sucked on. At first she was not sure; it had been a small, young tree; in the meantime, 45 years had gone by, but Ceija remembered that it had had a notch on its crown. She followed her feelings, went up to the tree—completely brittle and rotten as it was—and saw the notch, and knew it was "her" tree. She embraced it. And saw it all in front of her again.

At that moment, a thin branch broke from the dead tree. It had also died in the camp. She took the branch with her. As a sign, it is in each of her paintings.

My grandmother Ceija was very fragile but still a passionate, loving, strong, and unshakable woman who always stood behind her family. She began to paint on a day when she was watching me draw as a child. It must have been one of those many moments when she chose life again. The demons of horror plagued her until the end, but she never stopped threatening them. Ceija painted and wrote every day:

"Nature is my life. I like to hold on to a tree."

Vienna, April 2023

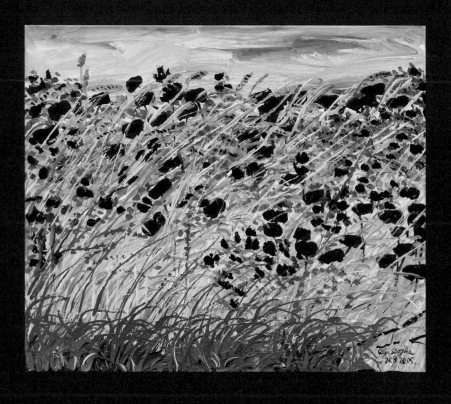

Fig. 3: Ceija Stojka, *I Love You*, 1995

CEIJA STOJKA'S MEMORY PICTURES OF LOVARA ROMA LIFE BEFORE WORLD WAR II

BY LORELY E. FRENCH

Ceija Stojka's paintings of "memories and feelings"[3] depict rare firsthand images of her Lovara family when they were in transit in their horse-drawn wagon, mostly from early spring to late fall, passing through the provinces of Burgenland, Styria, Carinthia, Upper and Lower Austria, and then often returning to Vienna to overw inter.[4] Their caravan usually included five wagons: that of her parents, those of her maternal and paternal grandparents and their families, and that of her father's brother.[5] They developed regular, familiar routes, frequenting the "Romana Thana," or the beautiful "stopping places"[6] to station the wagon while they pursued their livelihoods. Wackar Horvath, Stojka's father, traded horses, undertook metal work, and performed physical labor. Sidi Rigo Stojka, Ceija Stojka's mother, sold lace, fabric, handwoven baskets, and household wares, and told fortunes, often bringing the children with her. She also exchanged her goods and services for milk, bread, butter, and meat. The family thus did not just travel aimlessly, and they did not lead the purely nomadic, carefree life that the stereotypical image of being a "Gypsy" perpetuates..

Painting these scenes over fifty years later and over a span of almost thirty years, Stojka often adopts what viewers can identify as a child's perspective in depicting the richness and magnitude of the landscapes and her people's living conditions. The vast fields of poppies, cornflowers, and grains, as seen in the paintings *I Love You* (Fig. 3) are portrayed at ground level as if from a child's height. As the eye moves upward towards the background, the stems and blossoms extend almost endlessly towards the sliver of clouded sky. The swirling petals and swaying leaves on bent stems embody constant motion and a "vertical energy."[7]

The child's perspective does not make the paintings any less sophisticated in their technique, thematic content, and composition. Gobs of paint applied generously with fingers and even entire hands create texture. Stojka's signature branch in the lower right-hand corner, symbolizing her "Giver of Life" tree in Bergen-Belsen whose leaves and sap her mother encouraged her to eat to stay alive, looms large, reminding viewers that nature not only holds aesthetic beauty, but also sustains humans with food.

Indeed, objects that gain significance in a child's mind for their bright colors and marked shapes represent not only nature's beauty, but also her bounty. The ubiquitous sunflower, "the flower of the Roma," as she states in her poem, fulfills both aesthetic and nutritional desires and needs. (Fig. 4) One can eat the tender petals and the seeds. The sunflower also provided clothing, as Stojka tells the story of her father who once made her a skirt out of five actual sunflowers so that she could go to a Romani dancing festival.[8] Regarding foraging for other useful plants, she tells about going into the forest with her Aunt Gescha to gather yellow flowers that they brewed to make their "Gypsy tea."[9] She also learned from her Aunt Gescha how to make cough syrup from the tops of fir trees. Her family foraged for edible mushrooms and used the fat and innards from roasted hedgehogs as poultices against congestion. From the large Burgundy beets and meadow grains her family made fodder for the horses.

On a personal level, painting her "memories and feelings"[10] helped reclaim a childhood that was taken away much too early.

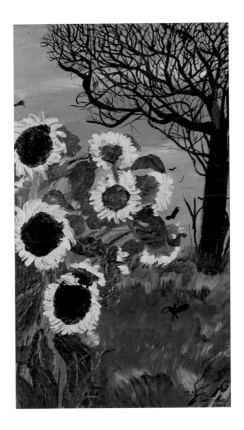

Fig. 4: Ceija Stojka, *Untitled*, 2007

On the collective, historical level, they assist in recreating the values, images, and customs of a people whose existence teetered on total extermination. The mobile wagon often stands at the center of artwork depicting these early childhood years and assumes a deeper purpose than being just a means of transportation and living space; her images transcend the pervasive stereotype of the perpetually wandering "Gypsy," which no longer coincides with the situations of most Roma today[11] (Fig. 5). As Moritz Pankok states, the depiction of wagons: "[. . .] nonetheless is a symbol of resistance against the dispossession of a culture, a traditional way of

life."[12] Indeed, the wagon and its many connected parts—the wooden body, wheels, horses, bedding, furniture, and cookware —and the natural settings that surround it appear ubiquitously as a constant life force. Conjuring up the wagon's image in her imagination became a source of inspiration for her paintings: "Yes, it was very idyllic. I did not learn to draw right, to compose the colors, and actually to arrange people was not easy when you have not studied all of this. But I did it with my games, with my fantasy, with the wagon right in front of me. After this, it comes out perfectly."[13]

The word for wagon in Vlachs Romany, which Stojka's family spoke and is still spoken by members of her extended family, is *wurdon* (singular), *wurdona* (plural).[14] Historical records show the houses-on-wheels carrying traveling menagerie and circus animals and their owners around Europe during the eighteenth and nineteenth centuries. The wagons in which Roma could live while they traveled to take up employment likely did not come into constant use until the mid-nineteenth century, and probably originated in France and then spread to the British Isles and parts of continental Europe.[15] Illustrations before the mid-nineteenth century show traveling people on foot or with carts living in tents.[16] Scholars have traced the early history of wagons that people could actually live in to the late-eighteenth and early nineteenth centuries, when Count Rumford (1753—1814) developed a design for "small ovens for poor families" and "a portable kitchen furnace" that would generate necessary heat.[17] The stove pipe protruding from the wagon's roof constitutes an ongoing motif in the wagons that Stojka depicts and indicates the presence of a stove with wood-burning capacities for inside the wagon. Stojka's visual imagery and her writings depict the building and sustaining of an outdoor fire to cook on, thus suggesting that the indoor oven was used primarily for heating, or for making the "Gypsy tea" that needed simmering all day.

The wagons that many Roma used, including the Stojka family, however, should not be confused with those of show people, which were usually ornately decorated. In contrast, Roma often prided themselves on being less materialistic and conspicuous,

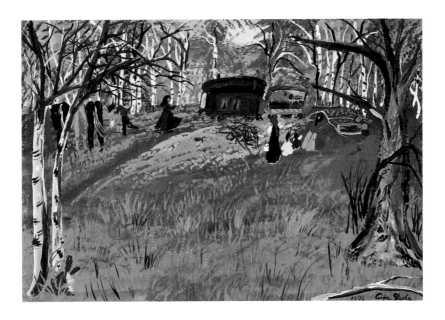

Fig. 5: Ceija Stojka, *Sidi, My Mother*, 1996

favoring nature over city in their travels and transactions.[18] There were companies that constructed and sold traveling wagons–the best-known being the so-called *vardo* for the "Gypsies" and Travellers in Great Britain with distinct styles such as the Reading, Burton, and Ledge by the Dunton family, and the Bow-top by William Wright. According to family members, however, the Stojka family either built the wagons themselves or purchased them homemade by local farmers, not only to stay within their financial means, but also in accordance with values of resourcefulness and utility as opposed to ornamentation and materialism. Stojka describes the wagons of her family and of their Roma acquaintances as follows:

> Some people had a so-called *Streifwagen*, which looked like a box wagon, with rubber wheels, about one meter high, completely flat inside. They often had a tarpaulin and stowed the children under it. The beds were wide; Roma had huge feather beds and pillows. The women placed a

high value on beautiful bedding with big flowers. Some also had real sleeping wagons, about three to four meters long, and the horses harnessed onto the front. When the weather was nice, the father sat outside with the whip and drove. When it was cold, he could open a window from inside and hold the reins from there, and we children in the back. Only, when a mountain came along, however, we always had to jump out. We were too heavy for the horses. We often had to give it a push, too. But it was nice when we came to a spot where there was forest, a stream. We would stop there. Mama made a fire, the children collected wood, and the parents cut down some grass with a sickle. Of course, they always made sure that they kept the place clean. Whatever was left over—potato skins or any kind of vegetable waste—they buried.[19]

The simpler, homemade quality also explains how Wackar Horvath could disassemble the wagon and construct a stationary house out of its parts, which he parked near Frau and Herr Sprach, who, Stojka states, built wagons. Such resourcefulness became indispensable when, under National Socialism, traveling people were forced to settle according to the Arrest Decree (Festsetzungserlass) of October 17, 1939. The wagons did, indeed, prove to be sources of resistance.

Despite its ability to be disassembled quickly, the wagon was sturdy. Stojka's description stresses its weight, which could become too heavy for the horses. In *They are Happy with What They Have, That is Freedom* (Fig. 6), the wooden box-like top appears to over-power the wheels. The wheel is, however, an important part of the wagon and a major symbol for Roma in general, as depicted in the Romani flag displaying a brown wooden wheel in the middle of a half blue and half green background, symbolizing the sky and the grass respectively as natural elements that Roma encountered while traveling. The wheels had to be light to traverse all kinds of terrain, but not pneumatic, which might be good on softer ground, but could spread and become unstable on hard surfaces.[20] Ceija refers to riding in the wagon of her godmother, also called Ceija,

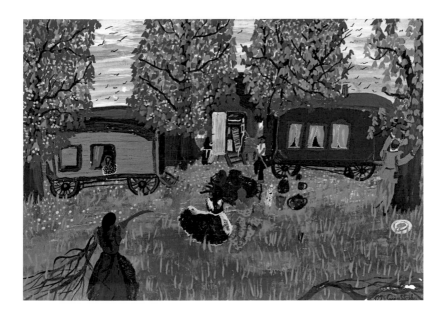

Fig. 6: Ceija Stojka, *They are Happy with What They Have, That is Freedom*, 1995

and her godmother's two sons.[21] Sometimes the wheels seem to disappear altogether, with the people even taller than the wagon itself, substantiating Stojka's observations on the wagon's heaviness as well as reflecting the child's perspective that what was happening outside the wagon was much more important than what might be occurring inside.

As the human figures in many paintings reveal, when the wagon pulled into the site, the men usually brushed and fed the horses and the women cooked over the fire; then the men, women, and children gathered straw for the beds. In the picture, the large size of the people outside of the wagon sometimes dwarfs the wagon, indicative of the child's perspective on how industrious and busy everyone is on the site and how unimportant the wagon as a place of rest becomes. The woman in the foreground of this painting is hauling a large, multi-branched tree limb on her shoulder. Pots and pans fill the fire spot, most likely with braising, slow-cooking meals.

One man in the center appears to be fetching something from the wagon. The other near the tree might be hitching up the horses, getting ready to feed and brush them. Two larger females in brightly colored dresses seem to be helping around the fire, while the face of one smaller child peeks out the wagon window, appearing to shake out a brightly printed fabric, perhaps one of the duvets. Again, everything and everyone is in perpetual motion: the women and children's hair is flowing to the side; and the men's arms are swinging. No one is just staring into the painter's and viewers' eyes. All are going about their business.

The wagon's homemade quality coincides also with the often irregular, slanting shapes of the top-heavy *wurdona* wooden cabins as they appear in Stojka's visual works as well as in historical photos. Far from being unserviceable, however, the wagon held everything that the family could desire while it remained neat, orderly, clean, and aesthetically pleasing. The wagons in the artworks have visible decorative blue, yellow, and white curtains in their windows. Stojka stresses the decorative effects of the wagon, even painting it in a pastiche of colors that blend in with the colors of nature. (Fig. 7) People slept in the wagons under bright, colorful, down-feather duvets. They were the pride of the women, who washed them in the stream and hung them out to dry in the fresh air during the day. The adults could also wash themselves and their children in the stream or, in this case, the nearby lake. On warm summer nights, Stojka slept outside, observing "the wagon wheels, the spokes, the long wagon tongue, the fresh grass, juicy and dark green."[22]

Of course, no wagon or family would be complete without its horses. Traveling could be treacherous, especially on underdeveloped mountainous roads. Not only the wagon had to show resistance to the natural elements; the horses, too, had to remain strong and healthy.[23] Humans and horses alike were family members, and, as experts in horse-trading, the humans gave the horses constant care and attention. Stojka describes the ritual of feeding and watering the horses as often being the first priority when the family arrived at their site for the evening. Horses figure prominently in her paintings.

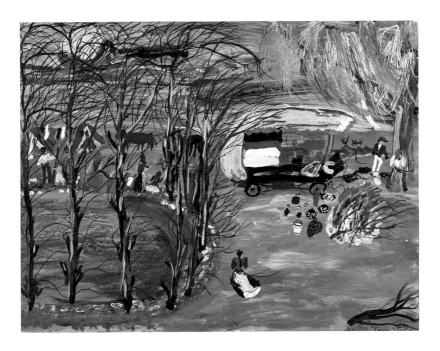

Fig. 7: Ceija Stojka, *Untitled*, 1993

A female figure, whom Stojka often identifies as her mother, Sidonie "Sidi" Rigo Stojka, is at the center of many of the Roma life portraits, reflecting the significant role that she played in family life. In the painting *Mama*, she stands proud and upright in the foreground, her red skirt glistens in the sunlight as she holds a pail in one hand and sunflowers in the other (Fig. 8). A wedding is in the background, evidenced by the bride's flowing white dress, veil, and train and the bridegroom's elegant black suit with tails and a top hat. Sunflower blossoms, sources of beauty, food, and clothing, appear everywhere in the painting, including mother's hands and hair; in the bouquets of the entire wedding party; and in the fields in the background.

By placing her mother front and center in many of her paintings, whether when depicting life in the wagon or revealing the horrors of the concentration camps, Stojka places high value on her work and roles in the family and community. Stojka thus demonstrates

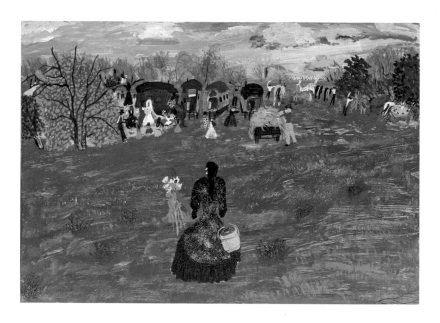

Fig. 8: Ceija Stojka, *Mama*, 1995

resistance to the patriarchal norms described in her memoirs. These norms include her father's disappointment at the birth of his second female child as opposed to the celebrations that occurred when boys were born, the negotiations over dowries and bride prices that had to be agreed upon when two people wanted to marry, the expectation that women remain virgins before marrying, and the opposition that her husband and brothers expressed when she began to write and then publish her memoirs.[24] Certain laws of purity and impurity—the latter are defined as *mahrime,* meaning ritually unclean as related to the body, hygiene, food, illness, birthing, death, and relationship with non-Roma—often affected women in particular. Birthing, for example, was not supposed to occur in the wagon, as Stojka relates in an interview. Her mother did not talk openly about labor pains when she was about to give birth, but rather stated in Romany "I palluni rota padschilli," or "The back wheel is breaking."[25] Stojka states that her mother would never have

asserted openly and directly that she was in labor; birthing was thus handled to show great dignity and respect. The family always had to look for a guesthouse or place outside the wagon to give birth. Painting the front cover of her book alongside a portrait of the wagon wheel engulfed by tall grasses evokes the symbolic meaning of another kind of "birth," that of her published memoirs[26] (Fig. 9).

As in the paintings of meadows and flowers, the artworks depicting the wagons also display a strong and genuine connection with nature. Sidonia Bauer analyzes the importance of nature, and especially trees, in Stojka's written work as they played dual, often contrasting roles in the family's private and public life.[27] On the one hand, trees provided shelter and refuge not only from inclement weather while traveling, but also as hiding places from raids by police and other authorities. Stojka refers to the *shudro baji* and *drien gopadscha*, the three trees, where the family knew they could camp.[28] When in the Kongresspark in Vienna, the children used the leaves to hide from the authorities hunting them down. The wagons in paintings such as *Mama* and *Romani Life* stand encircled by large trees that help to shade at the same time that they help to hide. Viewers' eyes must follow the expansive green grass in the foreground to reach the wagons dwarfed by trees and surrounded by people.

Trees in the paintings can also reveal ominous signals of hard times to come or of past traumas. In the sunflower painting, the beauty of the flowers' glorious yellows and green and stems stands in stark contrast to the leafless branches of the tree in the background. These signs of death in nature, as depicted from Stojka's perspective as an adult, indicate the ongoing discrimination and the mounting violence and persecution against Roma.

Still, Stojka never relinquished hope, neither as a child in the camps nor as an adult striving to educate younger generations and to prevent future discrimination, persecution, and genocides. In the painting with a rainbow gracing the entire sky, houses, and not wagons, dot the background, indicating that the times of life in the wagons are gone (Fig. 10). On the right side, workers are toiling in what appear to be rows of vegetables, while on the left side, the

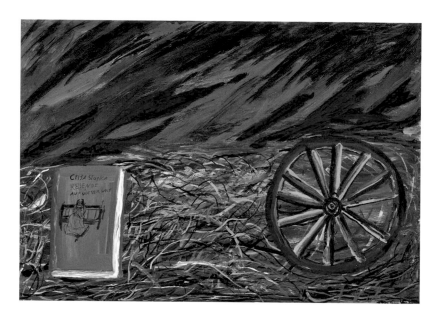

Fig. 9: Ceija Stojka, *I'll Never be Someone Else*, 1995

grains mixed with what could be blue cornflowers and red poppies in perpetual swaying motion. A blossoming tree separates the two sides. In the foreground, a leafless tree stands, again in contrast, etched against the abundant fields and foliage on the center tree. Despite this ominous sign of barrenness, even death, the rainbow spreads hope. The rainbow appears yet again in one poignant story at the end of *Am I Dreaming I'm Alive? Liberated from Bergen-Belsen*, she relates the story of standing with her mother in front of the crematorium in Auschwitz waiting in all the filth and stench for their impending death:

> But as we were standing there and the manure puddle
> next to me stank, and all the colors were playing in the oil,
> I said to my mother, 'Mama, look in there! What beautiful
> colors! Mama, I'd like to have a dress like that, in exactly
> these colors.' My mother said to me, 'What a mind you
> have! You're thinking of a dress while we're standing here!'

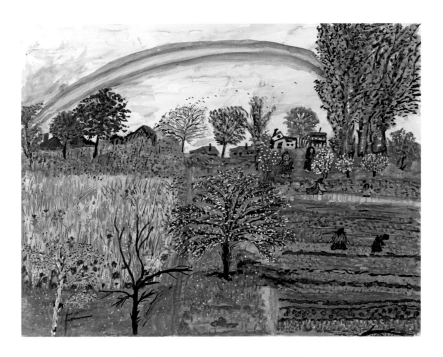

Fig. 10: Ceija Stojka, *Untitled*, 1993

When we were back in the barracks, I said to her, 'But Mama, when I come out, let's have a dress like that made. That'll be a rainbow dress!' Then she laughed, 'Oh yes, you mean one like your father made out of the material from that old umbrella.' 'Yes,' I said, 'I want to have one just like that!'[29] Amidst the horrors of unimaginable death in the last months before liberation, the imagination of the young child evokes memories and feelings about the creative resourcefulness of her deceased father who was interned in the camps at Dachau, Sachsenhausen, and Neuengamme and then gassed in November 1942 in the T4 euthanasia center of Hartheim in Upper Austria.[30] Layer upon layer, the memories and feelings she experienced as a child compound throughout adulthood to become symbols of resistance through painting, drawing, and writing.

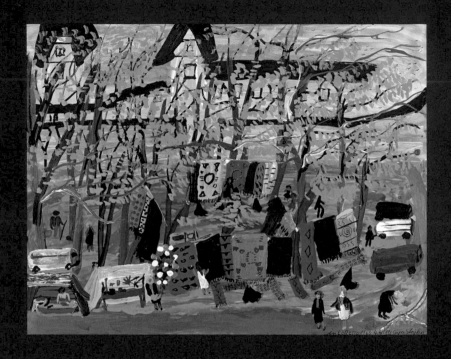

Fig. 11: Ceija Stojka, *Untitled*, 1993

OUR BATHTUB WAS THE BROOK *ii

POEM BY CEIJA STOJKA

Unsere Badewanne
war der Bach
unsere Heimat die Straße
unser Brot waren die Menschen
die es uns gaben
Unser Leid das sah niemand
Unsere Toten liegen in der Erde
Land wo sie geboren sind
Die Natur ist unsere Urmutter
Der Wind ist der Bruder des Romm
der Regen die Schwester der Romni
Und all das andere gehört dazu

Our bathtub
Was the brook
Our home the road
Our bread was the people
Who gave it to us
No one saw our suffering
Our dead lie in the soil
Land where they were born
Nature is our ancestral mother
Wind is the brother of the Rom
Rain the sister of the Romni
And everything else belongs to it

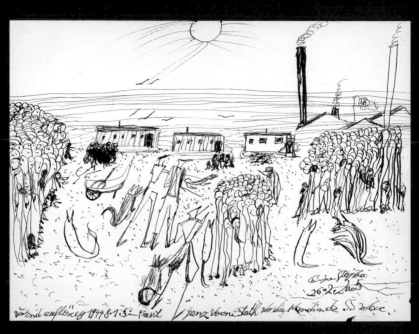

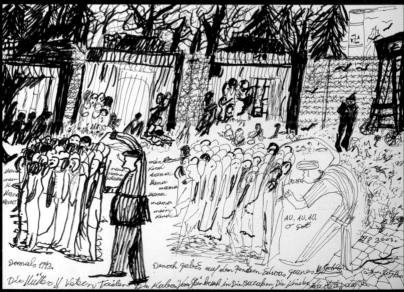

Fig. 12: Ceija Stojka, *The Final Solution, August 1, 1944,
Began up Front by the Canteen of the SS*, 2005
Fig. 13: Ceija Stojka, *Untitled (Mamo, my Child)*, 2003

THE SUNFLOWER IS THE FLOWER OF THE ROMA *iii

POEM BY CEIJA STOJKA

Die sonnenblume ist die blume des rom.
Sie gibt nahrung, sie ist leben.
Und die frauen schmücken sich mit ihr.
Sie hat die farbe der sonne.
Als kinder haben wir im frühling ihre zarten,
Gelben blätter gegessen und im herbst ihre kerne.
Sie war wichtig für den rom.
Wichtiger als die rose,
Weil die rose uns zum weinen bringt.
Aber die Sonnenblume bringt uns zum lachen.

The sunflower is the flower of the Roma
She provides nourishment, she is life.
And the women adorn themselves with her.
She is the color of the sun.
As children we ate her tender
yellow leaves in spring and in autumn her seeds.
She was important for the Roma,
more important than the rose,
Because the rose makes us cry.
But the sunflower makes us laugh.

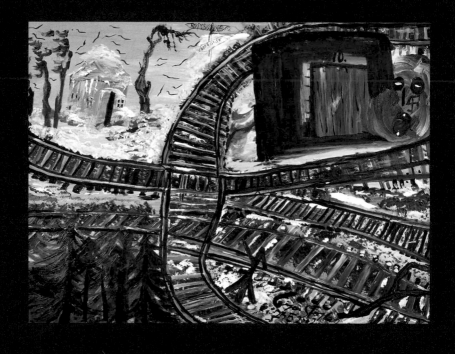

Fig. 14: Ceija Stojka, *Ravensbrück, Auschwitz, Bergen-Belsen*, 1995

THE NAZI GENOCIDE OF THE ROMA THROUGH THE EYES OF CEIJA STOJKA

BY MICHAELA GROBBEL

"Actually, I am still afraid that Auschwitz is asleep. Deep asleep. It could be woken up. Everything is still there.... And the people are there, too.[31]

These are the words of Ceija Stojka, who survived three Nazi concentration camps and became a unique artist and spokesperson for many Roma in the German-speaking world. Stojka used art to remember the history of the Nazi genocide of Sinti and Roma, referred to in Romany as *O Baro Porrajmos* ("The Great Devouring") or *Samudaripen* ("Mass Killing").

Stojka was nine years old when she, her mother, her sister Mitzi, and her brothers Karl, Mongo, and Ossi were arrested in the early morning hours in March 1943 and brought to the Rossauer Lände prison in Vienna. Her father had already been deported more than two years earlier on January 20, 1941, and had been killed.[32] Her sister Kathi had been detained for forced labor at the "Gypsy Camp" Lackenbach in Austria. The six siblings would meet again on their way to Auschwitz, when they had to switch from a passenger to a cattle train shortly behind the Czech border.[33]

The painting *Ravensbrück, Auschwitz, Bergen-Belsen* (Fig. 14) recalls the train ride to Auschwitz-Birkenau. Stojka talked about the long, horrific journey: people packed like animals in overcrowded, hot, and foul-smelling wagons, hunger, thirst, births during the ride, babies suffocating on the soiled straw stuffed in their mouths, and dead babies bound to mothers' bodies under their under-skirts.[34] The twisted train tracks in this memory image overlap with each other and create their own space filled with brownish red spots that recall traces of blood. Stojka also uses this color to paint her tree of life in the lower right corner as part of her signature, recalling the life-saving tree in Bergen-Belsen, whose emerging leaves, sap, and bark kept her and others from starvation shortly before the camp's liberation.

The painting is divided into four parts, pointing out the three Nazi camps by the town signs. The snake-like tracks ensnare a dark, ominous-looking building, marked with the number "10." This barrack represents the former block in Auschwitz-Birkenau, in which Stojka was crammed together with hundreds of inmates, often without a blanket. The oversized bright orange caricature of a face with a swastika beneath the left eye appears to be scream-ing orders with the black mouth wide open. The chin-long blond hair alludes to a female Nazi guard. The head's color connects with a trail of fire through and behind the prisoners' barrack.

In the barracks, as in *Block 10, 1943 Auschwitz* (Fig. 15), espe-cially after May 1943, overcrowding and catastrophic hygienic conditions caused the death of almost half the internees due to starvation, sickness, and ill-treatment by the guards.[35] In the "Gypsy Camp," between 800 and 1,000 prisoners were packed into thirty-two windowless, drafty former horse stables. In this work, the detainees directly look at the viewer, initiating an uncomfort-able exchange: A sea of bodiless faces, all heads pressed against each other, stare out, framed by the stark black beams of the three-tiered bunk beds. Corpse-like, they reflect the inmates' experience stripped of individuality and humanity.

In many of Stojka's works, ravens function as "God's ambassa-dors." They mediate between the two worlds: captivity, brutality,

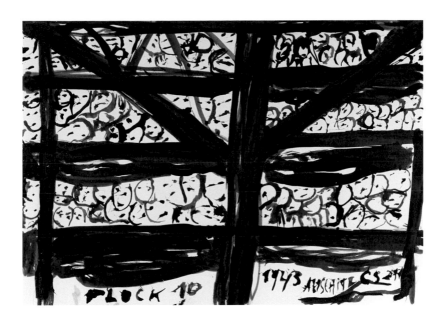

Fig. 15: Ceija Stojka, *Plock 10 (Block 10), 1943 Auschwitz*, 2011

and death on one side, and freedom on the other; they also serve as important witnesses to the atrocities. In *The Ambassadors of God, Auschwitz 1943* (Fig. 16), the viewer witnesses a raven in mid-air, picking away at the barbed wire resembling in part the bird's feet and wings. Above the wire fence, several more are flying away, creating an impression of a utopian moment of barbed wire dissolving into birds that are able to move freely in unlimited space.

Out of the estimated 11,000 Austrian Roma and Sinti, only about 1,500 survived the Nazi genocide.[36] *They Devoured Us* (Fig. 17) recalls the fear of "The Great Devouring." The viewer faces a ferocious-looking grayish animal, with blood-drawn eyes, mouth wide open and apparently ready to devour the viewer. The bloodstained mouth interior suggests a scary cavernous abyss of violent consumption. The swastika at the top of the creature's head reminds viewers that they are facing a Nazi officer, who is depicted as a

dehumanized creature. The drawing also captures the fear, viscerally experienced, of being killed. The reverse side of this drawing provides a commentary, apparently added ten years later, by only one color: The whole side is painted orange, which, according to Stojka, refers to the Austrian right-wing political party at the time, the *Bündnis Zukunft Österreich* (BZÖ).[37] Stojka's choice of color, used by the BZÖ in its promotional materials, expresses her alarm after 2005, when the party came into existence, about the re-emergence of xenophobic sentiments in Austria that scapegoated people of different ethnic and national identities as the root of social and economic problems.

SAMUDARIPEN: THE NAZI GENOCIDE OF THE SINTI AND ROMA

On January 15, 1933, a few months before Stojka was born on May 23, 1933, when her family was traveling through Austria, mayors and members of the parliament for South Burgenland met to address the "Gypsy question." The discussion included a proposal to deport Roma, classified as either "Zigeuner" ["Gypsies"] or "Asoziale" ["Asocial People"], to some island in the Pacific. This plan was never realized. The conference was just one sign among others that foreshadowed the systematic persecution and mass deportations in Austria, as well as forced labor and sterilization (already occurring in 1934, after the 1933 Law for the Prevention of Genetically Diseased Offspring), medical experimentations, starvation and death through fatal diseases, torture, and mass killings. The 1935 Nuremberg Race Laws in Nazi Germany tightened the situation considerably: They declared Sinti and Roma as people of "foreign blood," just like Jews, Blacks, Afro-Germans or so-called "bastards"; all groups were now "legally" marked for persecution. According to *The Memorial Book: The Gypsies at Auschwitz -Birkenau XIV* (1992), the first transport of 400 German Sinti already occurred in 1936.

SS-Reichsführer Heinrich Himmler's decree on December 8, 1938 explicitly presented the "final solution of the Gypsy Question." The expanded decree of March 1, 1939 declared Nazi Germany's

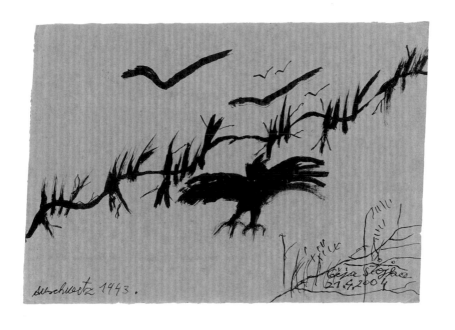

Fig. 16: Ceija Stojka, *The Ambassadors of God, Auschwitz 1943*, 2004

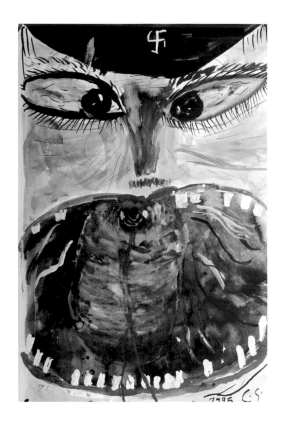

Fig. 17: Ceija Stojka, *They Devoured Us*, 1995

goal to maintain the "Aryan" German people through the segrega-
tion of the "Gypsies" and to prevent the mixing of "races."[38] Himmler
tasked the Racial Hygiene Research Center in Berlin, already
established in 1936 and directed by Dr. Robert Ritter, to record all
Sinti and Roma according to "racial" categories. Working closely
together with the criminal police, as well as other state and church
organizations, the team around Ritter compiled extensive genea-
logical and anthropological research on Sinti and Roma in Nazi
Germany, which was later extended to Sinti and Roma in Nazi-
occupied countries. By March 1944, Ritter's institute, which was

part of the Reich Health Office, had created almost 24,000 "racial evaluations," paying particular attention to Roma of mixed background or "Mischlinge." Nazi "scientists" established complex categories of "mixed Roma" that supposedly presented a special risk to the "health" and "purity" of the collective body of the "Aryan" people. These systematic records provided the basis for deporting hundreds of thousands of Sinti and Roma into Nazi concentration camps. One of the early mass deportations of 2,500 German Sinti and Roma to Poland took place from May 20–23, 1940, where they were interned in ghettos and labor camps, and forced to work in road construction, armament factories, or stone quarries.

Already before Hitler's "annexation" of Austria on March 13, 1938, supported by thousands of cheering Austrians welcoming Hitler to Vienna, a central office "to combat the Gypsy nuisance" was established in Austria's capital in 1936. Most Austrian Sinti and Roma lived in Burgenland, where many had settled at least since the 16th century, including Stojka's grandmother. Many of these Burgenland Roma were integrated as craftspeople, shopkeepers, or workers.[39] By 1937, however, the National Socialist German Workers' Party in Burgenland was openly inciting non-Roma citizens to "liberate" themselves from the Roma. Their goal to free the province from the circa 8,000 Burgenland Roma living there at the time, became a notorious slogan: "Burgenland free of Gypsies." Tobias Portschy, the Nazi governor of Burgenland, openly supported anti-Roma sentiments. In an extensive memorandum on the "Gypsy Question," he tapped into the centuries-old pool of stereotypes, misconceptions, and lies about Roma. He argued that they presented a "serious danger for the preservation of the purity of the German blood," that they were "burdened with hereditary and contagious diseases," and that they were lazy, untrustworthy, and professional thieves. His proposal included sterilization, and separating men and women in work camps to prevent procreation.[40]

Authorities in Berlin soon followed Portschy's rhetoric and specific proposals, so that Himmler's Circular Decree on Preventative Crime Fighting by the Police (December 14, 1937) was also applied to Austria. By June 5, 1939 the German Criminal Police informed

its Austrian office that the "Gypsies" or "Gypsy half-breeds" of Burgenland who were "work shy" and "asocial" be taken into "preventive custody." Men were to be transported to Dachau, women to Ravensbrück.[41] According to Gerhard Baumgartner, once Roma were taken into "preventive custody," the police were empowered to order the deportation of Roma suspected of being "work-shy" or supposedly unwilling to work to concentration camps.[42] The head of the school district in Oberwart/Burgenland wrote to an official in the Austrian Ministry of Education: "In order for this pest to disappear from the German milieu, I propose the painless but total sterilization of this race. Until they are finally disposed of one should employ them in forced labor."[43]

By 1938 the International Central Office for Fighting the Gypsy Menace had already recorded 8,000 Roma. Immediately after Hitler's so-called annexation of Austria, Austrian Roma and Sinti lost their civil rights, among them the right to vote. They were also forbidden to play music in public, which had been one of their primary sources of income. By May of that year Roma children were banned from attending school, and mixed marriages and sexual relations between "Gypsies" and "Aryans" were also prohibited.[44] An order from February 1939 forbade them from acquiring real estate.[45] The oppressive Nazi system closed in quickly on Austria's Sinti and Roma: By July 1938 the first Burgenland Roma were subjected to forced labor. In June 1939, 993 of them were sent to Ravensbrück and Dachau following the decree from June 5, 1939 to deport 3,000 "asocial" Burgenland Roma to concentration camps.[46] Three of the major Austrian "Gypsy Camps" were established in Lackenbach in Burgenland, Salzburg-Maxglan, and St. Pantaleon-Weyer in Upper Austria. The Lackenbach camp, in use by November 1940, detained a total of 4,000 Sinti and Roma, functioning as a collection site as well as a forced labor camp known for its "unbelievably atrocious standards of living, hygiene and alimentation."[47] Between the 4th and 8th of November, 1941, following Himmler's decree from October 1, 1941 ordering the deportation of 5,007 mostly Austrian Roma and Sinti, 2,000 Roma and Sinti were deported from Lackenbach to the ghetto in Lodz/

Litzmannstadt, where they were interned separately from Jewish detainees.[48] The catastrophic conditions, resulting in a typhus epidemic in the Lodz "Gypsy Camp," caused the death of hundreds of Roma just a few weeks after their arrival. Two months later, the remaining survivors, half of them children, were taken to Chelmno/Kulmhof concentration camp where they were killed in special execution cars through carbonic oxide gas.[49] Industrial killing had begun, although most Sinti and Roma in Nazi-occupied parts of Russia as well as Eastern and Southeastern Europe were shot, hanged, or killed by fire, and buried in mass graves between 1942 and 1943.[50]

After the "Auschwitz Decree" from December 16, 1942 had called for the deportation of all Roma to the Auschwitz-Birkenau extermination camp, the deportation of what would eventually be almost 23,000 European Sinti and Roma to Auschwitz-Birkenau began. At that time, about 10,000 Roma and Sinti from Germany and about 3,000 from Austria were forcefully transported to Auschwitz-Birkenau. Just like the Jewish and other victims, the Roma suffered from lack of food, water, hygiene, and brutal treatment on the way to the death camp. They were robbed of their homes, furniture, wagons, horses, jewelry, and money. The Nazis tried to annihilate their identity, too: Auschwitz inmates received a number tattooed on their arm upon arrival (babies on their upper leg), preceded by the letter "Z" for "Zigeuner." Sinti and Roma also had to wear black triangles sewn onto their clothing, which singled them out as "asocial elements," and their camp numbers. Upon arrival at Auschwitz-Birkenau, Stojka received the number Z 6399, tattooed on her left lower arm. This number would become an insoluble part of her life until her death in 2013, and she signed some of her works with this number, which she added to her name or her initials "C. S.," as well as to her sketch of a tree branch.

By the time the Stojka family was registered in Auschwitz-Birkenau, one of two mass murders had already taken place: In March and in May, a total of more than 2,700 Roma and Sinti were murdered in Auschwitz-Birkenau's gas chambers. By the end of 1943, 70 percent of the detainees in the "Gypsy Camp" had been

killed through starvation, violence, disease, or medical experiments, including many of Stojka's relatives and friends.[51] Children hardly had a chance to survive, and babies born in the camp had no chance. More than 18,000 out of the approximately 23,000 European Sinti and Roma, who were forcefully detained in Section B II e, known as the "Gypsy Camp," were murdered during the seventeen months, when the extermination camp existed. The "Gypsy Camp," close to the six gas chambers and four crematoria, included about 9,500 children up to the age of fourteen, among them 380 babies who were born in the camp.[52]

Stojka and her brother Ossi, two years younger than she was, had to carry stones for construction work. SS doctor Josef Mengele was one of the camp doctors in Auschwitz-Birkenau, where he started his infamous work in June 1943. Roma children were often misused for medical experiments, which most did not survive. Stojka's beloved brother died in May 1944 from typhoid fever after enduring medical experiments. All her life his sister mourned especially the loss of her little brother, which was deeply traumatic for her.

Stojka reflects her astute observations of life in the camps in her paintings and detailed drawings. The young Stojka paid attention to the victims as well as to Nazi guards and the different kinds of Nazi uniforms, boots, and pants. The painting of the Nazi boot, ready to march or kick a victim reveals the child's perspective from below (Fig. 18). The focus is on the ominous lower part of the boot partially raised as if it was worn by an SS officer. The focus on one empty boot, paralleling the vertical grayish paint strokes with the straight line of seam stitches, highlights the threats, strict commands, and fear the adult artist still remembered.

On May 16, 1944, the SS attempted to "liquidate" Section B II e by gassing all Roma. The night before, however, Tadeusz Joachimowski, a Polish prisoner and former member of the German Armed Forces, warned the Roma about the planned mass murder. According to his account, the approximately 6,000 Sinti and Roma resisted by using a variety of tools and improvised weapons.[53] Consequently, in late July 1944, 1,847 prisoners of the "Gypsy camp," who were considered physically strong enough for forced labor, were transferred to

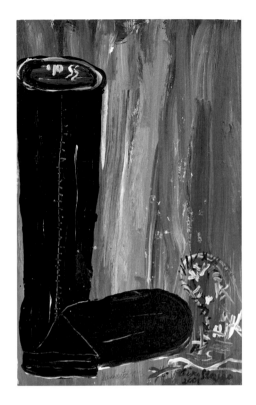

Fig. 18: Ceija Stojka, *Untitled*, 2001

Buchenwald, Mittelbau-Dora, Flossenbürg, and Ravensbrück, where they were used as enslaved workers for industrial factories, such as Siemens.[54] Stojka relates how she almost missed joining them: She was selected to go to the left, which meant she would have to stay and die, whereas her mother and siblings were ordered to go to the right side. They begged that Ceija join them and claimed she was sixteen already. Stojka passed a physical test to demonstrate her strength, and thus her life was spared.[55]

Thus, before the "liquidation" of the "Gypsy Camp," Stojka, her mother, and her sister Kathi were transported to the Ravensbrück women's camp. During the night of August 2 to August 3, 1944, at

least 2,897 Sinti and Roma who had been selected to remain in Auschwitz were killed in the gas chambers.[56] The killings of Sinti and Roma continued until the end of the war, where many more died in death marches from exhaustion, starvation, and brutality by the SS along with Jewish and other victims.

Much of Stojka's work displays the artist's desire to return dignity, beauty, and humanity to the victims of the Nazi terror. In *The Beautiful Women of Auschwitz* (Fig. 19) Stojka imagines a group of naked women and children who are about to die in the gas chamber.[57] One of them carries a child on her back. Some hug and support each other. One of the women hides her genitals, ashamed of her nakedness. In this work we witness beauty in the face of ultimate horror and destruction; dignity restored through art as a powerful medium of memory and imagination.

The past was present for Stojka. Always. As with many other survivors of Nazi concentration camps, her memories of the unspeakable terror remained with her every day—even more than six decades later after she and her family had been deported. The fact that "so many people, so many names," lives and stories, were lost in the Nazi camps haunted her for the rest of her life.[58] Stojka's work faces the trauma of Nazi extermination. Based on their history of centuries of discrimination and persecution, many Roma in Austria and other European countries have not acknowledged their traumatic past but rather continue to repress it in order not to incite more violence against themselves. Very much like Roma theater and Stojka's written work, Stojka's art helps strengthen Roma identity and sense of self-worth as well as work through the Romani history of persecution.[59]

Gabrielle Tyrnauer writes, "[although under] Hitler's rule, approximately half a million European Gypsies were systematically slaughtered.... [t]he Gypsies became the forgotten victims of the Holocaust" (p. 97). This neglect has been gradually changing once survivors and other Roma, such as Stojka, took the risk to break the silence. Ceija Stojka's unique memory paintings not only remember history but call on us today to stand up and fight against all forms of exclusion, inequality, and violence.[60]

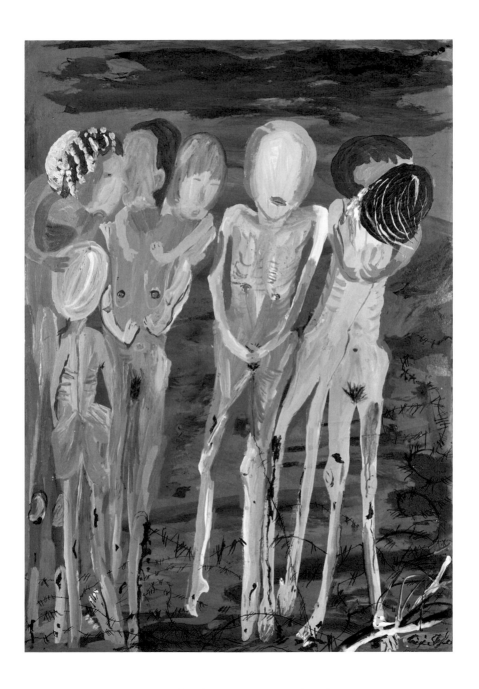

Fig. 19: Ceija Stojka, *The Beautiful Women of Auschwitz*, 1997

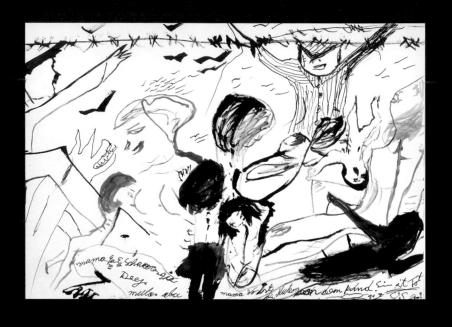

Fig. 20: Ceija Stojka, *Mama, Where is the Mother of the Child (Auschwitz)*, 2009

WE THE ROMA OF VIENNA, OH GOD*iv

POEM BY CEIJA STOJKA

Wir die Romm aus Wien	We the Roma of Vienna
o Gott	oh God
Oh ja wir wussten es	Oh yes, we knew it
und wir liefen liefen und liefen	and we ran ran and ran
umsonst o Gott	in vain oh God
und wir verkrochen uns o Gott	and we crept away oh God
Und Blüten fielen mit dem	and the blossoms fell with the
Wind vom Baum	wind from the tree
und wie wir liefen und liefen	and as we ran and ran
verloren wir auch unsere	we also lost our shoes
Schuh o Gott	o God
Und die zarten grünen Blätter	and the tender green leaves
konnte man schon sehen auf	you could already see them on
dem Ast	the branch
Und wir die Romm	And we Roma hid
wir versteckten uns o Gott	ourselves o God
so wie die Ameisen in	just like ants in the
der Baumrinde	tree bark
Und doch fanden sie uns	And still they found us
o Gott	oh God
sie die bösen Hakenkreuzler	they, the evil ones with swastikas,
o Gott o Gott	oh God oh God
Und so aßen sie die Äpfel	And just like that they ate the
vom Baum	apples from the tree
o Gott	oh God

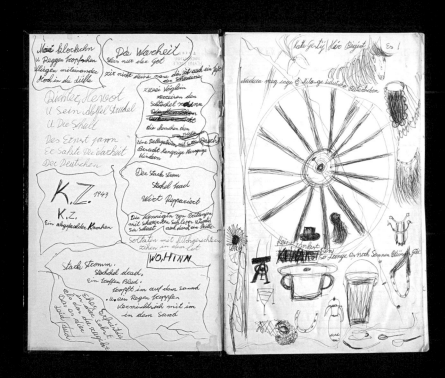

Fig. 21: Ceija Stojka, *Notebook*, book cover, 1993

IT IS DIFFICULT TO WRITE ABOUT SOME THINGS, BUT IT HAS TO BE

BY CARINA KURTA

Ceija Stojka has garnered acclaim during her lifetime as an activist and writer against forgetting, and posthumously as a visual artist. When Stojka died in 2013, she left behind a collection of over 1,000 artworks and manuscripts documenting her rich life. Among this treasure trove of multidisciplinary artwork are thirty-three notebooks that Stojka began creating in the mid-1980s and continued until the end of her life.[61] To open any page of these personal documents is to open a page into a fascinating world of cultural and historical insights that are as richly relevant today as they were during the decades of their creation. They are composed of prose, poetry, phrases, illustrations, titles, singular words, and expressions, originally in German and Romany. Stojka's notebooks can be described as vivid documents within the history of Roma in Austria and Europe and as a very personal assortment of art, literature, and social and political commentary.

My first contact with the family and the work of Ceija Stojka was in 2015. Working as a liaison between the curators, the exhibition centers, and the Stojka family, I regularly read through the notebooks, which had their place in the cupboard between the living room and the kitchen in her son Hojda's and his wife Nuna's Viennese apartment. With time I became increasingly conscious of

the fragility of these spiral-bound notebooks and the importance of this part of her life when she was writing almost daily. In 2018, I applied and received funding to archive and digitally preserve high-quality images of the notebooks in order to contribute to the legacy of this testimony. During an intense time of two years of reading through the notebooks, I created an index of their content.

"Reading an artist's diary is the next best thing to being there [...]."[62]

Going through Ceija's thoughts, the reader dives into the perspective of a woman being haunted by her childhood memories and confronted with the tough life as a Romani Holocaust survivor in Austria. However, when attempting to place these objects into a larger artistic, literary, cultural, and historical context, the challenge of categorizing them and finding comparable records by other artists and writers arises. Taking a look into history, we come across several records by famous writers and artists, such as William Blake, Vincent van Gogh, and Frida Kahlo, all of whom also combined text and visuals. Kahlo's so-called "diary" seems most similar to Stojka's, as it combines vivid artworks and experiments with language in the form of captions, poems, and short prose.[63] Vincent van Gogh's letters are a fascinating parallel, as writing certainly had a therapeutic value for both authors.[64] The notebook as a means to record works-in-progress was also true for William Blake. Blake covered pages with both texts and illustrations, having the tendency to pick up his notebooks later again for further comments, texts, or adding illustrations—as Stojka did.[65]

Beyond the idea of a diary, Stojka's written work has to be considered particularly in the context of a survivor. Only a small number of diaries and journals of children who suffered persecution and incarceration during World War II are known, reflecting fragments of each writer's life in a great variety of personal backgrounds. These diaries show a complex view of young people who lived and died during the Holocaust.[66] The largely autobiographical dimension of the diaries often becomes a kind of "intimate archive" of self-reflection, conveying a subjective historicity.

The diary of Anne Frank might present one famous model due to the similar experiences of children during the Holocaust. Both Stojka (b. 1933) and Frank (b. 1929) were deported to Auschwitz-Birkenau and then Bergen-Belsen in the winter of 1944/1945. Anne Frank died in Bergen-Belsen; her diary with her testimony of her young life in hiding was published by her father in 1947. Ceija survived, and was liberated from Bergen-Belsen on April 15, 1945. Frank wrote while the events were happening, and while she was hidden in Amsterdam before being arrested. Stojka only started to write in her late fifties, partly talking about the time in hiding before she was deported to Auschwitz in 1942. Her entries depict memories mostly about experiences in the concentration camps from the point of view of an adult woman who assumes the perspective of a child again.[67] While Frank's diary focuses on text, Stojka combines both writing and visuals. Frank also seems more intent on preserving privacy, given the necessity to stay in hiding; in addressing her diary with the fictional character "Kitty," she purveys an intimacy that at times makes the reader feel like an intruder. Stojka also shares a kind of intimacy with her books. In about a third of the notebooks, which I have examined thus far, she thanks the books for receiving her thoughts, ideas, and emotions, and for "having listened" to her. She refers to the books as "Büchlein" (little books) or "Buch" (book) or "Heft" (notebook). This special relationship far from the eye of the public might have helped her to gain confidence in writing. As an autodidact who was denied schooling when younger and who entered the second grade after the war at the age of twelve, she writes as she speaks, frequently spelling phonetically and employing a stream-of-consciousness style with little or no punctuation. Indeed, in the notebooks, she often admits to how uncomfortable she feels about making mistakes in writing and orthography, and when she turns seventy years old, she says it is fine to make mistakes.

Stojka published her memoirs in three books in 1988, 1992, and 2005. It seems that the first original handwritten manuscript, written down as neatly as possible, before being typed using a typewriter, constituted the earliest existent notebook and it formed the basis for her published memoirs, which Karin Berger helped edit. She relays

Fig. 22: Ceija Stojka, *Notebook, The Origins of My Pictures*, 1995

her reminiscences in a clear, unfiltered manner. The later notebooks, less well-known and mostly unpublished, are an immeasurable source of information about the last thirty years of her life and reflections on personal, contemporary Austrian, European, and global events. Meticulously and almost daily, she describes insights into her world of thoughts, writes poems or expresses her reflections via illustrations. It seems that text and image become equal ways of expression (Fig. 21). She begins to relate more to current events that are preoccupying her. While she deals with personal situations emotionally, her writing also forms a socially critical commentary. Political reflections about Austria play an essential role, especially in connection with the change of government and the conservative and extreme right-wing coalition that was formed in 2000. In addition, providing insight into Stojka's world of thought, the notebooks are fonts of information about her personal network, ranging from acquaintances and key cultural and political figures, to family.

The 33 notebooks were listed chronologically. The notebook 6/33 contains several turning points of Ceija Stojka's life. The title of my essay here cites from an important document from book 6, a personal, yet unofficial testament Ceija wrote in 1995, where she underlines "It is so difficult to write about some things but it has to be."[68] In this document she expresses her wish that her legacy may be continued for the sake of her children, with the support by the "majority society". The following example takes up another passage, with "The Origins of My Pictures" (Fig. 22).

DIE ENTSTEHUNG MEINER BILDER

Ich malte immer mit meiner Enkelin Sidi (Kosename Pönchen) genannt. Sie ging kaum noch in die Schule doch zu malen das konnte sie, sie ist wirklich gut. Doch malte ich auch manches mal mit meiner größeren Enkelin Simona, sie besucht die Steiner Schule. Mir gefielen die Farben, das Bunte auf das Papier zu bringen, ja nur so zum Spaß und dabei blieb es auch, einstweilen. Nun wurde mein Buch

präsentiert, Titel *Wir Leben im Verborgenen*, und nicht lange darauf brachte mich dieser Titel bis nach Japan. Japan holte mich zu einer in Japan diskriminierten Tagung der Burakus 11 Tage verbrachte ich in diesem herrlichen Land, ein Land dort wo die rote Sonne einen so warm streichelt, ich lernte viele liebe Japaner kennen. Ging von einer Tagung zur nächsten, auch war an einem Tag Hiroschima auf unserem Plan, Schulen und wieder Altersheime, Kindergarten, Parlament-Besuche. Ein Treffen verschiedener Regenten, ein Besuch auf Japans Friedhof, ein Besuch bei einer riesigen Fernsehen (Fernsehsender), Gipsfabrik und noch mehrere Krankenhäuser, Blumenhändler, Museen und das Unterdrückungsdenkmal für gefallene Burakus, ja und vieles mehr. Damals 1989 wusste ich nicht, daß auch in einem der reichsten Länder Japan auch Menschen unterdrückt wurden, ja auch in diesem schönen morgenrötischen Land haben viele keine Chance, doch mir schenkten alle wo ich war ihr ehrliches Herz, am 10. Tag meiner Reise fand ein Symposium statt, der vorletzte Tag, alle reichten mir Ceija ihre Hände. Den Kindern in Japan, die im Kindergarten sind versprach ich werde euch nie vergessen. Und ich werde euch ein Bild von meinen Enkelkindern schicken, ich dachte dabei an Mona oder Sidi, die Kinder in Japan und ihre Heimmutter jubelten und klatschten, ja es wollte nicht aufhören mit streicheln und immer nur lächeln musste ich mich von ihnen verabschieden, ja ich musste rasch gehen, denn es war viel zu schön doch auch traurig.

Zuhause angekommen saß ich mit meiner kleinen Enkelin Sidi, ein Zeichenblatt ich schon für die kleine Pönchen auf den Tisch gelegt und auch schon bunte Wasserfarben. Pönchen malte, doch dann holte sie ihre Mutter wieder ab. Das halbfertige Blatt lag auf dem Tisch, es war für mich sehr sehr schön, doch was jetzt. Mit etwas Scheue nahm ich den Pinsel in meine Hand, ich strich von blau zu grün,

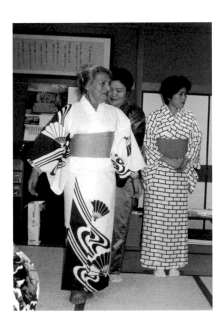

Fig. 23: *Ceija Stojka during her trip to Japan,* December 1989

rot und braun, die Farben ließen sich das gefallen. Und so
entstanden 2 Bilder. Meine ersten, die schickte ich auch so
wie versprochen nach Japan. Für die Kinder im
Kindergarten in Osaka. Doch die vielen bunten Farben
ließen mich nicht los. Denn da war etwas, das mich
geduldig aufnahm, im Gegenteil das weiße leere Blatt
streckte sich geduldig vor mir aus, es gefiel mir sehr und
immer wenn es meine Zeit erlaubte vergaß ich die Zeit mit
meinen bunten Farben, sehr oft schimpfte Kalman mit mir,
er meinte was machst du da für einen Blödsinn und was
bringt dir das. Nun versuchte ich dass es nicht vor ihm ges-
chieht. Alle meine lieben Sachen, Farben, Pinsel und die
Malpalette wanderten mit mir in die Küche. Es ging gut,
doch hörte ich manches Mal leise trabende Schritte, jaja,
es war wie immer Kalman und dann lachte er, wenn er sah,
dass ich den Pinsel auf die Maltasse lag, das tat ich wenn

ich ihn hörte, nur um Frieden zu haben. Ich ließ mich nicht und durch nichts außer dass es wirklich wichtig war aufhalten, ich fiel in die Farbe als wäre sie für mich geschaffen. Es holte mich ein. Es entstanden die Erinnerungsbilder, ich brauchte keinen geeigneten Platz auszusuchen, ich hatte so viele eigene in meiner Erinnerung, in Gedanken holte ich mir eine bestimmte Erinnerung aus meinem Kopfe uns schon hatte ich die Stelle fixiert. Die Blätter häuften sich, ich dachte, meine Kinder werden sich einmal die Sachen anschauen und somit wissen sie wie und wo ich damals nach dem 2. Weltkrieg auch als Reisende mit meiner Mama gut unterwegs war.

THE ORIGINS OF MY PICTURES[69]

I always painted with my granddaughter, Sidi, whose nickname was "Pönchen." She had hardly started school but she could paint. She is really good. But sometimes I also painted with my older granddaughter Simona. She went to the Rudolf Steiner school. I liked the paints, putting colors to paper, yes, only for fun and yet it continued, for the time being. Then my book *We Live in Secrecy* was published and not long afterwards, this title brought me to Japan, where I attended a conference about the discrimination of the Burakus there.[70] I spent 11 days in this marvelous country, where the red sun caresses you so warmly. I got to know so many kind Japanese people. I lived from one day to the next. One day, Hiroshima was on our schedule as well as schools, retirement homes, kindergartens, and visits to the parliament. There were meetings with various dignitaries, a visit to a Japanese cemetery, a visit to a huge television (television station), a plaster factory, and several more hospitals, florists, museums, and the monument to the oppression of the fallen Burakus, yes, and much more. At that time, in 1989, I didn't know that even in one of the

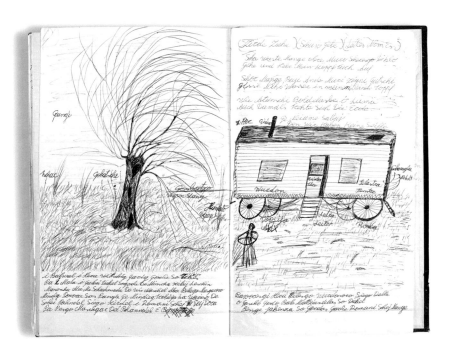

Fig. 24: Ceija Stojka, *Notebook, Wurdon/Wagon*, 1993

richest countries, Japan, there were also oppressed people; yes, even in this rosy-dawned country, many people didn't stand a chance, and yet wherever I went, everyone graciously gave me their heart. A symposium took place on the tenth day of my trip, the next-to-last day, and everyone gave me, Ceija, their hands. I promised the children in Japan, the ones in the kindergarten, that I would never forget them. And that I would send you a painting by my grandchildren. I was thinking about Mona or Sidi. The children in Japan and their housemother cheered and clapped, yes, the caressing didn't stop, and still they were smiling when I had to say goodbye to them. Yes, I had to leave quickly, because it was much too beautiful and yet sad. At home I sat with my little granddaughter Sidi, a sheet of drawing paper laid down on the table for little Pönchen as well as her colorful watercolors. Pönchen painted, and then her mother picked her up. The half-finished picture lay on the table. I found it really beautiful, and so immediate. I took the paintbrush into my hand somewhat shyly and tentatively, I stroked from blue to green, red and brown; the paints liked this. And that's how two pictures originated. I sent the first ones to Japan, as promised, for the children in the kindergarten in Osaka. But the many colorful paints held my attention, because there was something that patiently kept me completely absorbed; on the contrary, the empty sheet of white paper spread itself out patiently in front of me. I liked it, and whenever time allowed, I forgot the time when I was with my colorful paints. Very often Kalman scolded me. He wondered what I was doing with that nonsense and what it would bring me. Then I tried not doing it in front of him. All my beloved things, paints, brushes, and the painter's palette came with me into the kitchen. It was going well, and yet, sometimes I heard quiet, steady footsteps, yes, it was always Kalman, and then he would laugh when he saw that I had laid the brush into the paint cup, I did that when I heard him, only to get some

peace. I never stopped unless it was something really important. I dove into the paints as if they had been made for me. It completely absorbed me. The memory pictures arose, I didn't need to search for any designated spot, I had so many of my own in my memories. From my thoughts I would pull out a certain memory from my head and soon I was fixated on the place. The sheets of paper piled up, I thought, my children will look at these things someday and that's how they will know how and where I was when I was traveling along well with my mother after World War II.

While describing the historical facts of her trip to Japan in December 1989, Stojka expresses her concerns about suppression, minorities, and war, which accompanied her all her life. However, the positive part of the trip, the smile on the faces of the people, especially the children in the kindergarten, takes over (Fig. 23). She wants to give something back to them. And after the unsuccessful attempt to engage the grandchildren (Simona and Sidi) to participate, it happens: the paper patiently spreads out in front of her. In this key moment, the colors, the paper, and the artist merge into each other, and she will never let it go again. Her detailed description of this moment emphasizes the importance of the scene.

We know of no other notebooks by Romani artists, writers, activists, or survivors of the genocide of Stojka's generation. Thus, Stojka's notebooks deserve wider dissemination. Publishing relevant excerpts and linking them to corresponding artworks helps to illuminate Stojka's artistic process and historical testimony on contemporary history and provide a vital opportunity for aesthetic, literary, and historical enjoyment as well as preservation, referencing, and further research. One of the objectives of the Ceija Stojka International Association is the continuing work on an accessible online platform to view the vast extent of the notebooks in conjunction with Stojka's impressive artworks and life experiences. We hope that this first published text on Ceija Stojka's notebooks gives a sense of the wealth, importance, and necessity of recording her voice through her notebooks (Fig. 24).

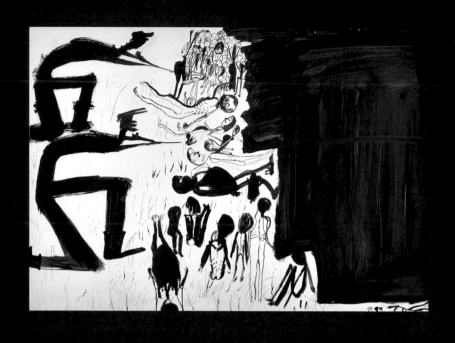

Fig. 25: Ceija Stojka, *Untitled (Bergen-Belsen)*, 1995

AUSCHWITZ IS MY OVERCOAT*ᵛ

POEM BY CEIJA STOJKA

Auschwitz ist mein Mantel
du hast angst vor der finsternis?
ich sage dir, wo der weg menschenleer ist,
brauchst du dich nicht zu fürchten.
ich habe keine angst.
meine angst ist in auschwitz geblieben
und in den lagern.
Auschwitz ist mein mantel,
Bergen-Belsen mein kleid
Und Ravensbrück mein unterhemd.
Wovor soll ich mich fürchten?

Auschwitz is my overcoat
You are afraid of the darkness?
I tell you: wherever the way is devoid of people
you don't need to be scared
I'm not afraid.
My fear stayed in auschwitz
and in the camps.
Auschwitz is my overcoat
Bergen-Belsen my dress
And Ravensbrück my undershirt
What should I be afraid of?

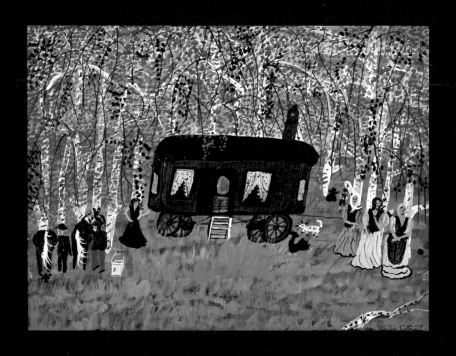

Fig. 26: Ceija Stojka, *Untitled*, 1993

THE ART OF CEIJA STOJKA CONTEXTUALIZED

BY STEPHANIE BUHMANN

Ceija Stojka's grasp on humanity is immediately captivating. Her subjects range from the worst that human beings have inflicted on each other to the healing serenity of nature and the power of community that extends to family and beyond. When depicting people, she usually focused on groupings, an indicator of how well she understood our interdependency, forming the very fabric of our world. It was Stojka's steadfast belief in people's ability to comprehend and learn from this that ultimately encouraged her, in her mid-50s, to tell her devastating story.

Though it was her personal history that Stojka was sharing, she recognized it as an example of a fate that had befallen hundreds of thousands of Roma and millions of victims of National Socialism, reflecting the profound impact of the historical events on both individual lives and collective memory. By the time she started to express herself in writing, drawing, painting, and even music, she was a mother and grandmother. When working, she kept in mind those who would follow in her wake. Indeed, her oeuvre of over one thousand works of art serves as a testament and a reckoning for her family and future generations, created in the hope that hate would never regain such monstrous dimensions; that by recalling a beautiful pre-war world that had been lost she could describe the level of happiness that is attainable when united with family and connected

with nature. As an activist, Stojka aimed to educate younger generations, recognizing that hate continued to persist even after the war, and old prejudices remained prevalent. The fear of history repeating itself was the undercurrent of her life and work.

Most of Stojka's drawings and paintings focus on experiences she had during the first twelve years of her life, which remained ever-present for her. Together, they mark an outstanding illustrative and extensive exploration of loss, survival, and perseverance. Stojka's darkest hours largely comprised the years between 1938 and 1945. An index card containing three headshots of Stojka, captured by the Reich authorities in 1938 as part of the special registration imposed on all Roma, signifies a clear beginning to the nightmare that was about to unfold, leading from harassment, to persecution, imprisonment, and the murder of beloved family members and friends. The photographs, which resemble criminal mugshots, capture a strong but fearful young girl, torn away from her joyful childhood and standing on the precipice of the *O Baro Porrajmos* ("The Great Devouring"), the term the Roma would later use to describe their genocide by the Nazi regime. The viewer is confronted with the horrifying experiences of this girl, encompassing her time at the Rossauer Lände prison, Auschwitz-Birkenau, Ravensbrück, and Bergen-Belsen. These scenes depict a harrowing reality of constant fear, brutality, death, starvation, murder, and *Menschenverachtung* (contempt for humanity).

Stojka's oeuvre contrasts these illustrations of terror with the harmonious prewar life that she experienced in her youth as a member of a tight-knit Lovara family, who traveled through Austria by horse and wooden wagon. One of the emblematic works on that subject is an untitled gouache on paper from 1993 (Fig. 26), which presents the family's home in the center of the composition. While the foreground shows a lush green meadow, the background features a dense birch forest. It is the kind of landscape that Gustav Klimt had also rendered between 1901 and 1902, when painting the forests around Litzlberg at Lake Attersee. Similar to Klimt, Stojka depicted the birch trees by truncating their tops, giving them a distinctive iconic presence and transforming them into

Fig. 27: Ceija Stojka, *Untitled*, 1991

natural columns. In Stojka's case, this enhances the somewhat theatrical quality of the scene, which is further reflected in the way most of the protagonists are arranged in a curved line on the left and right sides of the wagon. While the men, engrossed in caring for the horses, have their backs turned to the viewer, the women face forward, forming an attentive welcoming committee. Behind them, children can be observed playing, while a cat and chicken peacefully roam near their feet.

While there are more exterior pre-war scenes such as these in Stojka's oeuvre than depictions of life inside the wagon or interiors in general, another work from 1991 marks an exception (Fig. 27). The broad wooden floorboards, the curvature of the back wall, and the hints of a wooden ceiling suggest that this composition may indeed be inspired by the kind of wagon that was used by Roma traveling through Austria.[71] It is an intimate, highly personalized space that exudes an immediate sense of comfort, achieved through the generous use of vibrant colors and different textiles. Notably, a woven carpet and two plush seating arrangements contribute to the inviting atmosphere. An underlying equilibrium is evident in the composition, with many decorative details appearing in pairs. For instance, two gold-colored candelabras, two oval framed pictures of flowers, and two elaborate fans adorn the wall, while two green pillows are placed on the floor. As a counterbalance, a dark wooden table dominates the center and divides the space evenly. On it, we find a vase with a bouquet of branches, which again is evenly parted in order to point at the cycle of life. While the left half is in bloom, the right bears fresh green leaves only. Meanwhile, three cups, an open book, and some apples add to the overall domesticity while also hinting at the presence of its inhabitants. Stojka's generous use of the color red for the wall, pillows, carpet, and other details not only unifies the composition but also evokes a connection to Henri Matisse's renowned painting *Red Studio* (1911)[72] and his interest in Orientalism, especially when related to the use of patterned textiles and decorative objects. While this might be coincidental, it is worth noting that similar to Matisse, Stojka, who worked in the intimate setting of her home

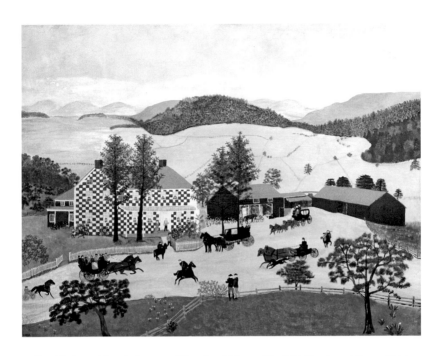

Fig. 28: Anna Mary Robertson, "Grandma" Moses, *The Old Checkered House*, 1944

rather than a studio, summons various sources of her creative inspiration in this work. It is filled with objects and themes that consistently inspired her throughout her life: textiles, plants, text, the cycle of life found in nature, and an implicit sense of relaxed communal gatherings as it is implied here even without anyone present.

In their idealized quality, Stojka's depictions of prewar life on the road can be contextualized with the works of the American Folk artist "Grandma" Moses (1860—1961), who also began only later in life to paint a world that she remembered from her childhood but which had since vanished. Born in 1860 and having grown up on a farm in Upstate New York, Moses was seventy-seven years old when she began to compose nostalgic scenes of a bygone era. In her work, rural life stands in stark contrast to the realities of the Industrial Age, which had gathered momentum during her lifetime

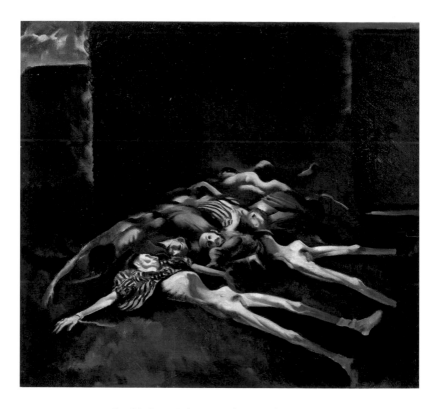

Fig. 29: Doris Zinkeisen, *Belsen: April 1945*, 1945

(Fig. 28). Certainly, the biographies of both women are strikingly different, yet their lighthearted portrayal of their early years are rooted in a similar perspective: that of an observant child who views her harmonious surroundings with a blend of awe and innocence. While Stojka's trust in a kind world was soon shattered, the richness of her oeuvre in depicting these contrasts between the before and after adds to its overwhelming tragedy.

Take Stojka's recollections of Bergen-Belsen, for example. In her memoirs, she recalls how from the very first moment, even before entering the camp, dead and dying prisoners could be found everywhere. "You couldn't even count how many were lying there, one

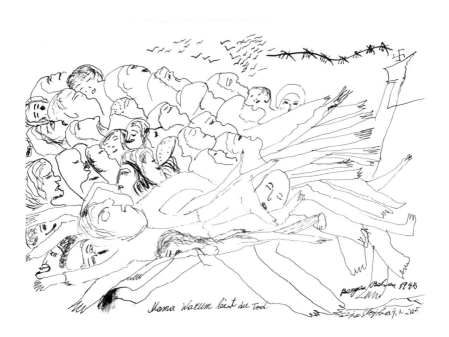

Fig. 30, Ceija Stojka, *Mama, Why are You Dead? Bergen-Belsen, 1945*, 2005

on top of the other, young and old, some of them still alive."[73] It is a motif she would revisit repeatedly and her unique perspective on this gruesome reality becomes even more clear when compared to the work of an entirely different artist, the Scottish portraitist Doris Zinkeisen (1898—1991). Zinkeisen, who until that point had enjoyed considerable success for society and equestrian portraits, was sent by the British Red Cross as the first officially commissioned artist to document Bergen-Belsen after its liberation by the British Army on April 15, 1945. Upon entry, Zinkeisen encountered the approximately 60,000 remaining inmates, among them Stojka and her mother. She also would have seen the 13,000-odd unburied corpses that remained in the camp at the time.

To compare Zinkeisen's *Belsen* from 1945 (Fig. 29) with Stojka's *Mama, Why are You Dead? Bergen-Belsen, 1945* (2005, Fig. 30) means comparing two powerful but very different approaches to

the same subject, completed sixty years apart. While Zinkeisen had been in her 40s when she observed the scenes, Stojka had been less than twelve years old. Both Zinkeisen and Stojka focus on the dead as they lay about the camp in various states of decomposition. In both examples, viewers are instantly struck by the way the dead are piled up, without dignity or care for their individual storylines. To Zinkeisen, these nightmarish scenes were filled with anonymous victims, but to Stojka, they embodied more than that. She described how she would seek shelter among them, without fear: "If the dead hadn't been there, we would have frozen. So I crawled in, with my head stuck outside and my feet stuck inside."[74]

Stojka's drawing, made when she was in her 70s, describes almost tenderly the individual victims while her words, written in cursive letters hover above the scene, summing up her unbelievable sadness and disbelief in one succinct question: "Mama, why did you have to die?" Overall, Stojka's work is rich in empathy for those whose lives were taken, but also for those left to mourn them, including children. She often reminds us that the notion of loss expands with the number of those who remember those who were lost; that there is no closure. In fact, Stojka recalled how when revisiting Bergen-Belsen years later, the dead appeared in her dream, greeting her, welcoming her back.[75]

It is characteristic for Stojka to look back at this hellish time with contemplative clarity. In her painting *Bergen-Belsen 1945* (1996, Fig. 31), flames and smoke engulf the camp barracks in the distance; the fire was started by the British Army to avoid the spread of typhus. Meanwhile, the vast stretch of barren land in the foreground is almost entirely charred by a previous fire ignited by the SS camp guards in order to eliminate the evidence of their monstrosities. The few details that can be made out describe mainly the upper third of the composition: remnants of wire fencing rendered in white and a lush green tree. In this context of death and destruction, the latter seems out of place, taking on symbolic meaning as the only reflection of life. It is oblivious to the horrors that occurred in its proximity, surviving in spite of it all. Stojka wrote and spoke

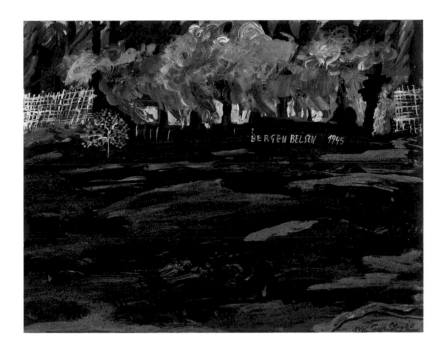

Fig. 31: Ceija Stojka, *Bergen-Belsen, 1945*, 1996

repeatedly of such a tree in Bergen-Belsen, which had contributed significantly to her survival: "In front of our barracks stood a single deciduous tree. I can't imagine how it got there. It had beautiful, thick, light-green leaves. It wasn't very tall, so you could grab the leaves. They had a sweet taste and were thick and juicy [...] I called our beautiful tree 'Giver of Life'."[76] It is a signifier of hope that is altogether missing in *Birkenau, 1944* (Fig. 32). Here, Stojka divided the picture plane into two segments. Red and yellow flames are all around. Built up in thick layers, they are swallowing up a sea of human heads. Faceless, they make up an anonymous mass of lives doomed to be extinguished in agony. It is a scene imagined by Stojka and it becomes a vehicle for our own imagination. The lack of fore- and background forces us to find ourselves included in the scene, to join the victims visually in their inescapable torment.

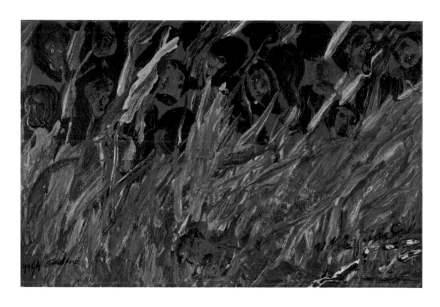

Fig. 32: Ceija Stojka, *Birkenau, 1944,* 2007

Throughout Stojka's oeuvre, it is women who feature most prominently. In fact, in her consistent focus on their suffering, most importantly as it pertained to the fear of losing and mourning their dead children, Stojka's themes are as timeless as they are existential and can easily be related to the works of some other female artists of the twentieth century, including Käthe Kollwitz, Charlotte Salomon, Frida Kahlo, and Alice Neel. All of them experienced tragedy at first hand, which, combined with their gift of empathetic and clear observation, permeated their work and provided it with awe-inspiring depths (Fig. 33).

For example, both Kollwitz and Neel had lost children; Kahlo struggled with physical trauma after barely surviving a major accident as a teenager; and the Berlin-born Salomon spent her youth in hiding in Southern France until her deportation and murder in Auschwitz in 1943. Stojka did not portray herself to the extent that Kahlo, Kollwitz, Neel (less frequently) and Salomon did, but her work is not less inclusive of autobiographical details.

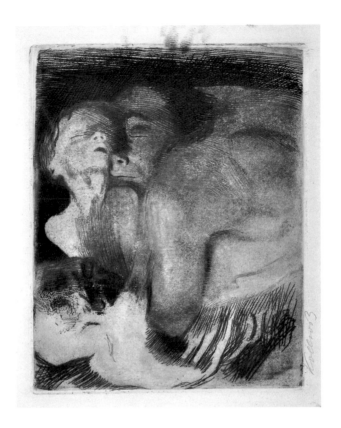

Fig. 33: Käthe Kollwitz, *Death and Woman Fighting for the Child*, 1911

In Stojka's depictions of others, we witness her own transformation over time: from the young girl observing life unfolding before her to the adult artist reflecting upon subjects embedded in her own past.

One of Stojka's most moving drawings is entitled *Off to the KZ!* (1995, Fig. 34). It depicts a group of women standing close together, seeking shelter where there is none. Tears are streaming down their faces. Children are clinging to their skirts. One woman is holding a naked baby tightly to her chest. In the background, NS officials can be seen with their mouths distorted, shouting orders with teeth

bared and their eyes filled with hate. The composition of the drawing is organized diagonally from the center-left side of the page to the upper right, accentuated by two parallel lines of barbed wire towards the upper edge. This arrangement creates a sense of a growing, wave-like movement, as if this scene is just a glimpse of a much larger context. Despite the trauma they are subjected to, the women are unified in their shared experience. Still, by rendering their faces carefully, Stojka bestows each with a sense of explicit individuality, effectively contrasting the humanity of the women with the dehumanized portrayal of the NS officers and therefore creating a clear visual distinction between the oppressed and their oppressors.

In 2022, another female artist gained international recognition for exploring the rich heritage of the Roma after exhibiting both at documenta 15 and the Venice Biennale, where she represented her native Poland. Born in 1978 in Zakopane, Malgorzata Mirga-Tas grew up in the Romani settlement of Czarna Góra at the foot of the Tatra Mountains. Community marks a substantial aspect of her work, both conceptually and practically. She creates monumental collages made of pieces of recycled clothing, many of which are donated by family and friends. In fact, members of Mirga-Tas's social circle often assist in the labor-intensive sewing process of these textiles rich in personal and traditional references. Like Stojka, Mirga-Tas frequently focuses on the life of women and draws attention to the past. Her work *May*, which belongs to the series *Re-enchanting the World* (2022, Fig. 35) even includes a portrait of Stojka while seated. A few years prior to that, Mirga-Tas's *Monument to the Memory of the Holocaust of the Romani* (2011) was erected in Southern Poland. Featuring a crouching female figure, the sculpture commemorates twenty-nine Roma who were murdered in that particular place by German soldiers and Polish police in 1942. It represents a significant number of victims, underscoring the unfathomable scale of the *Porrajmos*, with estimates of up to 500,000 Roma lives lost. The fact that Mirga-Tas's work was later vandalized reveals the level of hate that Roma are still facing in different parts of the world today. It also serves as a shocking reminder that works

Fig. 34: Ceija Stojka, *Off to the KZ!*, 1995

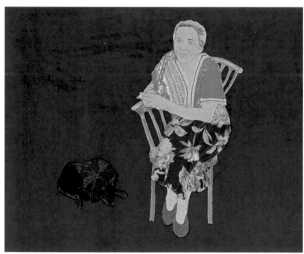

Fig. 35: Malgorzata Mirga-Tas, *May*, from the series *Re-enchanting the World*, 2022, which includes a depiction of Ceija Stojka seated.

such as these, including Stojka's recollections, do not exclusively deal with injustices of the past. Rather, they serve as an outcry against silence, which equates with denial, marks the first step toward forgetting, and therefore aids in paving the road for history to possibly repeat itself.

In its entirety, Stojka's oeuvre manifests itself as a call for remembrance. Her works confront viewers with unspeakable crimes and suffering. Her deep empathy renders her subjects as dignified individuals, except for those she feared, those who threatened and destroyed. They become part of a monstrous machine, not always faceless, but certainly without soul. It is the strength of Stojka's work that she invites viewers to follow her through both darkness and light. And it is indeed light we find when joining her, her family, and larger community in bucolic landscapes covered in spring flowers, thick woods, and rolling hills while resting together next to lakes, rivers, and meadows. It is these moments of respite that enable us to face the dark moments in Stojka's oeuvre. She believed that despite all the misery, humans are not hopeless, life is never senseless, and true light is inextinguishable.

TO MY CHILDREN, GRANDCHILDREN, AND GREATGREATGREATGREAT GRANDCHILDREN*vi

POEM BY CEIJA STOJKA

An meine Kinder Enkel und
Urururur-Enkel und auch
an die die meine mutter hat geboren
Ich hab mein Leben mit Euch gelebt
und ich war damals
selbst noch ein Kind
deswegen habe ich mit Euch alles miterlebt
Wir lachten miteinander wir weinten
mit einander
Wir teilten jeden Schmerz auch
mit einander
Wir teilten jedes Stück Brot mit einander
Wir sind sehr stark verwurzelt mit einander
Wir liebten das Leben ja doch mit einander
Wir machten Musik und sangen mit
einander
Wir erreichten die Reife des Lebens
mit einander
Wir mussten sogar den Hass tragen
mit einander
Wir wurden auch sehr alt mit einander
Wir lieben den Himmel und die Sterne
mit einander

To my children, grandchildren, and
greatgreatgreatgreat
grandchildren, as well as
To those my mother gave birth to
I have lived my life with you, and back
then I was
still a child myself
Therefore, I have experienced everything
along with you
We laughed together, we cried together
We also shared every pain together
We shared every piece of bread
together
We are closely entwined together
We really did love life together
We made music and sang together
We reached the maturity of life together
We even had to carry hate together
We also got old together
We love the sky and the stars together

Wie lieben die Bäume das Gras ja die
Natur mit einander
Wir lieben die Sonne den Mond mit
einander
Wir lieben den Regen den Tau das
Meer mit einander
Wir hatten kein Haus für uns mit einander
Wir verloren viele Verwandte an den
Tod mit einander
Und doch sind und waren wir glücklich
mit einander
Denkt immer auch dies und das auch
mit einander
Was auch geschieht wir lieben Gott
und Maria mit einander
Einmal werde ich gehen von Euch nicht
mit einander
Also macht keinen Unsinn Ihr alle mit
einander
Und passt auf Euch auf so wie einst
mit einander
Ich werde dort drüben auch nicht
allein sein
Im Jenseits werde ich mit unseren
Vorangegangenen
einander sein
Ihr alle ich liebe Euch so wie Ihr seid
mit einander
Also bringt Blumen Vergissmeinnicht
und das auch mit einander
Denn mit einander haben wir das Leben
leben gelernt
Ja ich weiß Ihr werdet sagen Du Mama
war es nicht so
Doch das Leben mit den Meinen
es war herrlich
Und es war so Und noch eins
Ich war 16 18 22 als ich Euch gebar
Glaubt ja nicht dass ihr so jung seid
Ihr kommt auch bald zu mir
Eicha Mama Mami Eure Schwester Ceija

We love the trees the
grass, yes, nature together
We love the sun, the moon together
We love the rain, the dew, the sea together
We had no house for ourselves together
We lost many relatives to death together
And still we are and were happy together
Think also always about this and that together
Whatever happens we love God
and Maria together
Some day I will go away from you,
not together with you
So don't you all do anything crazy together
And look after each other like
back then together
I also won't be alone on the other side
In the hereafter I will be together
with our ancestors.
All of you, I love you as you are together
So bring flowers, forget-me-nots and
do that too together
For together we have learned to live life
Yes, I know you will say, You, Mama
wasn't it like that
But life with my people was glorious
And it was like that. And one other thing
I was 16, 18, 22 when I bore you
Don't think that you are so young
You will soon also visit me
Your Mama, Mami, Your Sister, Ceija

Fig. 36–41: Austrian Cultural Forum New York, *What Should I Be Afraid of?*
Roma Artist Ceija Stojka, May 23–September 25, 2023, Installation views.

84

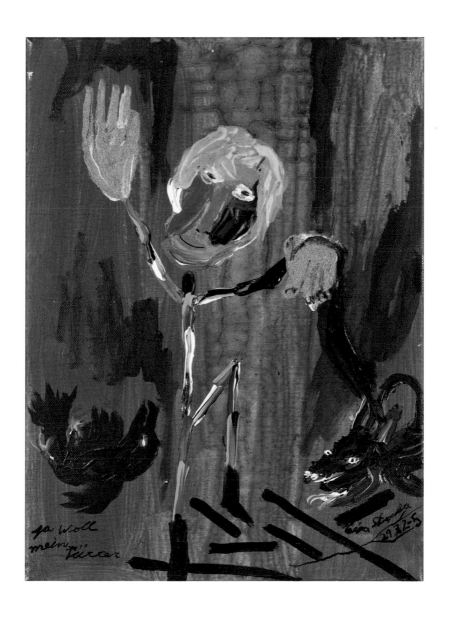

Fig. 42: Ceija Stojka, *Yes My Führer*, 2005

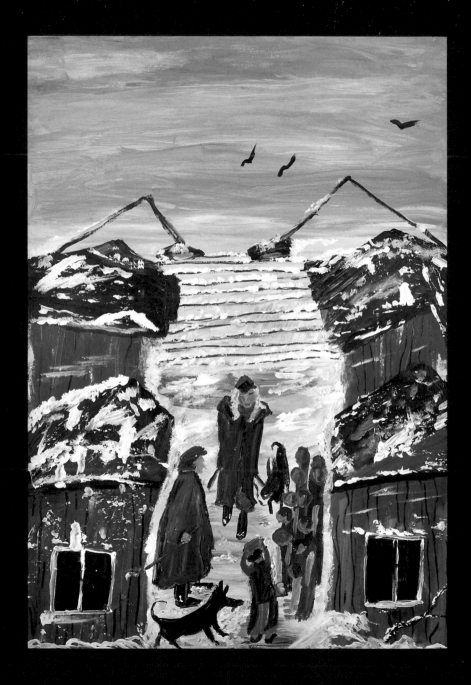

Fig. 43: Ceija Stojka, *Untitled (Ravensbrück)*, 2001

NOTES

1 In Romani cultures, a Gadjo, plural Gadje, with all variations in the different Romani dialects, is usually used for a non-Roma person. Fergus Smith, *Romany-English Glossary*, March 1998. Available online under: http://www2.arnes.si/~eusmith/Romany/glossary.html.
2 Rom (pl. Roma): male member of the group, "Romani husband" and Romni (pl. Romnja): female member of the group, "Romani wife", Definition by RomArchive: Available online under: https://www.romarchive.eu/en/terms/rom-romni/.
3 The expression "memory pictures" comes from a notebook entry from October 13, 1991, entitled "The Origins of My Pictures" (2018_12_CP_CSCARNETS_056).
4 The Lovara were one of five known main Romani groups in Austria during the interwar period, including Arlije, Burgenland-Roma, Kalderas, and Sinti. The Gurbet, a sixth major group living in Austria today, began arriving in Austria in the 1960s, largely from parts of what was then Yugoslavia. Lovara, known for their expertise as horse traders, arrived mostly in the second half of the nineteenth century from areas of what are today Hungary and Slovakia. See: Gerhard Baumgartner, "Der Genozid an den österreichischen Roma und Sinti," in: *Romane Thana: Orte der Roma und Sinti*, ed. Andrea Härle, Cornelia Kogoj, Werner Michael Schwarz, Michael Weese, and Susanne Winkler, Vienna: Wien Museum, Landesmuseum Burgenland, Initiative Minderheiten, Romano Centro, and Czernin Verlag, 2015, pp. 86—93, here p. 9; Dieter W. Halwachs, "Romani in Österreich," in: Dieter W. Halwachs and Florian Menz, eds. *Die Sprache der Roma: Perspektiven der Romani-Forschung in Österreich im interdisziplinären und internationalen Kontext*, Klagenfurt: Drava Verlag, 1999, pp. 112—46. The essays in this volume use "Roma" as a term for all the groups, which is now a common practice.
5 Ceija Stojka, "Sie waren vom Stamm der Lovara" in: *auschwitz ist mein mantel: bilder und texte*. Vienna: edition exil, 2008, p. 11.
6 According to Nuna Stojka, Ceija Stojka's daughter-in-law, the term "Romane Thana" refers specifically to the beautiful places, and not just any place, where Roma stopped. See *Romane Thana: Orte der Roma und Sinti*, 2015.
7 Deborah Solomon uses this expression to describe Vincent Van Gogh's renditions of cypresses in the exhibit "Van Gogh's Cypresses" at the Metropolitan Museum of Art from May 27—August 27, 2023. Indeed, art critics could draw several parallels between Van Gogh's and Stojka's paintings of landscapes and flowers. Deborah Solomon, "Van Gogh and the Consolation of Trees," New York Times, May 11, 2023; updated May 14, 2023. com/2023/05/11/arts/design/van-gogh-cypresses-met-museum.html.
8 Ceija Stojka, Interview with Lorely French, January 9, 2009.
9 Ceija Stojka, "So kochten die Romnja/Kadej kiravenas e Romna," in: *Fern von uns im Traum … Märchen, Erzählungen und Lieder der Lovara/Te na dikhas sudende … Lovarenge paramiči, tertenetura taj gjila*, Petra Cech, Christiane Fennisz-Juhasz, Dieter W. Halwachs, and F. Heinschink Mozes, eds., Klagenfurt: Drava, 2001, pp. 280—89; Lorely French, "How to Cook a Hedgehog: Ceija Stojka and Romani Cultural Identity. Through the Culinary Arts," in: Cuisine and Symbolic Capital: Food in Film and Literature, Cheleen Ann-Catherine Mahar, ed. Newcastle upon Tyne: Cambridge Scholars Publishing, 2010. pp. 104—29.
10 Stojka used this expression to describe her paintings in my interview with her in January 2009.
11 The Romani scholar Ian Hancock stresses that "only a tiny fraction" of the world's twelve million or so Roma are traveling year round without a stationary living place. Hancock, "'Uniqueness' of the Victims: Gypsies, Jews and the Holocaust," *Without Prejudice: The*

EAFORD International Review of Racial Discrimination 1.2 (1988), p. 50.
12 Moritz Pankok, ed. *Ort des Sehens/Kai Dikhas/Place to See 2: Damian Le Bas, Gabi Jiménez, Imrich Tomáš, Ceija Stojka, Kiba Lumberg, Nihad Nino Pušija.* Berlin: Edition Braus/Galerie Kai Dikhas, 2012, p. 90.
13 Interview with Lorely French, January 9, 2009.
14 I thank Nuna Stojka for this information; one sometimes also sees the spelling as *vurdon*. The word is probably from Ossetic, European Welsh/Romni: Fergus Smith, *Romany-English Glossary*, March 1998. Available online under: http://www2.arnes.si/~eusmith/Romany/glossary.html
15 C.H. Ward-Jackson and Denis E. Harvey with drawings by Denis E. Harvey, *The English Gypsy Caravan: Its Origins, Builders, Technology and Conservation*, Newton/Abbot: David & Charles, 1972. I am indebted to Sidonia Bauer for this reference and for the idea to look more closely at the wagon image in Stojka's paintings. See: Sidonia Bauer, "Arguments on the empowerment of Sinti*ezze and Rom*nja through the resource of social space in traveling communities," in: *Approaches to a "new" World Literature. Romani Literature(s) as (Re-)Writing and Self-Empowerment*, eds. Lorely French and Marina Ortrud Hertrampf, Munich: AVM, forthcoming 2024.
16 Ward-Jackson and Harvey, p. 39.
17 Ibid., p. 28.
18 Ibid., p. 38. Of course, there were Roma who were performers and show people who prided themselves on their ornate wagons. German Sintezze Philomena Franz, who belonged to a family of traveling performers, describes the family's wagon with loving detail: Philomena Franz, *Zwischen Liebe und Haß: Ein Zigeunerleben*. 1st edition 1985. Freiburg, Basel, Vienna: Herder, 1992, p. 14.
19 Ceija Stojka, *The Memoirs of Ceija Stojka*, trans. by Lorely French, Rochester, N.Y.: Camden House, 2022.

pp. 183-84. Hereafter cited as *Memoirs* with the appropriate page number.
20 Ward-Jackson and Harvey, p. 62.
21 *Memoirs*, pp. 77–78.
22 Ibid., p. 85.
23 Ibid., p. 89.
24 These norms surface in Stojka's interview with Karin Berger "You mustn't be anyone else: Interview with Ceija Stojka," in: Ibid., pp. 175–208; specific passages referred to here are on pages 191 (sons valued over daughters), 177 (husband and family against her writing), and 187 (marriage customs and virginity).
25 Berger and Stojka, "'You mustn't be anyone else: Interview with Ceija Stojka," *Memoirs*, p. 190.
26 Besides the painting pictured here with her second book, another one exists with her first book. On the back of that painting she wrote "A wheel and a book are rolling. Ceija Stojka 18. 12. 1994." *Ceija Stojka (1933–2013): Sogar der Tod hat Angst vor Auschwitz/Even Death is Terrified of Auschwitz/Vi O Merimo Daral Katar O Auschwitz*, ed. Lith Bahlmann and Matthias Reichelt, Nuremberg; Verlag für moderne Kunst, 2014, p. 376. I thank Stephanie Buhmann for noting this correlation between the wagon wheel, birth, and book publication in this artwork.
27 Sidonia Bauer, "Écrivaines samudaripiennes: les Lager de Stojka et Franz," in: Marina O. Hertrampf and Kirsten Hagen, eds., *Romani Aesthetic(s)—self-and external representations*, Munich: AVM edition, 2020, pp. 205–36.
28 Berger and Stojka, "'You mustn't be anyone else': Interview with Ceija Stojka," *Memoirs*, p. 192.
29 *Memoirs*, p. 174.
30 *Schreibstubenkarte Dachau, 1.1.6.7/10664269/International Tracing Service (ITS) Digital Archive, Bad Arolsen.*
31 Interview with Grobbel, September 15, 2011.
32 *Memoirs*, p. 42, footnote 4.
33 Mongo Stojka, *Papierene Kinder: Glück, Zerstorung und Neubeginn einer Roma-Familie in Osterreich*, Vienna: Molden, 2000, p. 96.

34 Interview with Grobbel, Sept. 15, 2011. French and Grobbel conducted many interviews with Stojka before and after the 2009 art exhibit, entitled LIVE-DANCE-PAINT: Works by Romani ('Gypsy') Artist Ceija Stojka. They organized the first exhibit in the USA of Stojka's work, which included the artist's commentaries on her art.
35 Romani Rose (ed.), *The Nazi Genocide of the Sinti and Roma,* 2nd. rev. cd, Heidelberg: Documentary and Cultural Centre of German Sinti and Roma, 1995, p. 136.
36 Karola Fings, "Die Anzahl der Opfer," RomArchiv, 2019. Available online under: https://www.romarchive.eu/de/voices-of-the-victims/the-number-of-victims/.
37 Statement made during a conversation between Stojka and the author in the summer of 2006.
38 Silvio Peritore and Frank Reuter, "Der Nationalsozialistische Völkermord an den Sinti und Roma: Ein Überblick," in *O Kalo Phani/Das schwarze Wasser: Das Denkmal für die im Nationalsozialismus ermordeten Sinti und Roma Europas,* Berlin: Edition Braus, 2012, pp. 28—29.
39 Rose, p. 72.
40 Gerhard Baumgartner, "Sinti und Roma in Österreich," *pogrom* 130 no. 6 (1987): p. 48.
41 Guenter Lewy, *The Nazi Persecution of the Gypsies,* New York: Oxford UP, 2000, pp. 57—59.
42 Baumgartner (1987), p. 7.
43 Lewy, 61. Excerpt from letter by Bezirksschulrat Wilhelm Kasper to Kurt Krüger, March 29, 1939.
44 Gerhard Baumgartner, "Roma and Sinti in Austria," in his: *Gypsy Camp Lackenbach. List of Identified Victims 13.11.2010. In Commemoration of the 70th Anniversary of the Establishing of 'Gypsy Camp Lackenbach' on the 23rd of November 1940,* Vienna: KANZLEI, 2010, p. 7.
45 Lewy, p. 59.
46 Barbara Danckwortt, " The ground beneath our feet was very hot and black: human dust.' — Auschwitz, Ravensbrück, Bergen-Belsen," in: *Ceija Stojka (1933—2013): Sogar der Tod hat Angst vor Auschwitz/Even Death is Terrified of Auschwitz/Vi O Merimo Daral Katar O Auschwitz,* Nuremberg: Verlag für Moderne Kunst, 2014, 416; cited from Gerhard Baumgartner and Florian Freund, eds. *Die Burgenland-Roma 1945—2000: Eine Darstellung der Volksgruppe anhand qualitativer und quantitativer Daten,* Eisenstadt: Amt der Burgenländischen Regierung, 2004, p. 28.
47 Baumgartner (2010), pp. 9—10.
48 Rose, p. 99.
49 Peritore and Reuter cite the written testimony of Jewish prisoner Szlojme Fajner, who witnessed the murders (31). See also Ruta Sakowska, *Die zweite Etappe ist der Tod: NS-Ausrottungspolitik gegen die polnischen Juden, gesehen mit den Augen der Opfer,* Berlin: Edition Hentrich, 1993, p. 166.
50 Polish historian Piotr Kaszyca identified about 180 of these mass graves, but the number may be even higher. Peritore and Reuter (p. 31) discuss the findings based on the article by Piotr Kaszyca, "Die Vernichtung der Roma im Generalgouvernement 1939—1995," Dlugoborski W. (ed.), *Der 50. Jahrestag der Vernichtung der Roma im KL Auschwitz-Birkenau,* Oswiecim: Vereinigung der Roma in Polen, 1994, pp. 94—100).
51 Danckwortt, p. 420.
52 State Museum Auschwitz-Birkenau, *The Memorial Book: The Gypsies at Auschwitz-Birkenau XIV,* Munich: K.G. Saur, 1993, p. 4.
53 The nature of this resistance still needs more research. See, for example, the critique of the depiction of the May 16 resistance: Helena Kubica and Piotr Setkiewicz, "The Last Stage of the Functioning of the *Zigeunerlager* in the Birkenau Camp (May—August 1944)," *Memoria: Memory, History, Education* 10 (July 2018), pp. 6—15. Available online under: https://view.joomag.com/memoria-en-no-10-july-2018/0531301001532506629.
54 Rose, p. 136.
55 Ceija Stojka. *Leben im Verborgenen,*

Karin Berger, Vienna: Picus, 1988, pp. 31—32.

56 Published numbers vary but range between 2,897 up to 4,300 murdered Roma, according to the Memorial and Museum Auschwitz-Birkenau, "News: Sixty-First Anniversary of the Liquidation of the Gypsy Camp in Birkenau," Aug. 8, 2005. Available online under: https://www.auschwitz.org/en/museum/news/sixty-first-anniversary-of-the-liquidation-of-the-gypsy-camp-in-birkenau,427.html and https://www.auschwitz.org/en/history/categories-of-prisoners/sinti-and-roma-gypsies-in-auschwitz/). Since 1997, August 2 has been observed as Roma Extermination Remembrance Day.

57 Interview with Grobbel, August 7, 2006.

58 Interview with Grobbel, September 6, 2011.

59 Michaela Grobbel, "Crossing Borders of Different Kinds: Roma Theater in Vienna," *The Journal of Austrian Studies*, 48.1 (2015), p. 1.

60 In her published writings, Stojka also asks her non-Roma readers to rethink stereotypical images of Roma as well as the relationship between dominant and ethnic minority cultures. See Michaela Grobbel. "Contemporary Romany Autobiography as Performance," in: *German Quarterly, 76.2 (2003),* p. 150.

61 The granddaughter of Ceija, Simona Anozie, explains that her mother Silvia encouraged Ceija to write down her thoughts in the 1980s. Ceija suffered from nightmares, and her daughter Silvia suggested to her that writing down her thoughts would help her to sleep better.

62 "A Day in the Life: Artists' Diaries from the Archives of American Art," Exhibition from September 26, 2014—February 28, 2015. Available online under:https://www.si.edu/exhibitions/day-life-artists-diaries-archives-american-art%3Aevent-exhib-5576."Reading an artist's diary is the next best thing to being there. Direct and private, diaries provide firsthand accounts of appointments made and met, places seen, and work in progress—all laced with personal ruminations, name-dropping, and the occasional sketch or doodle. Whether recording historic events or simple day-to-day moments, these diary entries evoke the humanity of these artists and their moment in time."

63 Museo Dolores Olmedo, "A Peek at Frida Kahlo's Diary." Google Arts and Culture. Available online under: https://artsandculture.google.com/story/a-peek-at-frida-kahlo-s-diary-museo-dolores-olmedo/AWxmDksayhmJA?hl=en.

64 Vincent van Gogh, "The Letters," ed. by Leo Jansen, Hans Luijten and Nienke Bakker, Amsterdam: Van Gogh Museum; The Hague: Huygens Institute KNAW, October 2021. Available under: https://vangoghletters.org/: The project on the Van Gogh letters provides the entire collection of correspondence of Vincent van Gogh. It was digitized and analyzed for fifteen years as part of a major research project and is accessible online.

65 "William Blake's Notebook 1794." British Library Learning Timelines: Sources from History. Available online under:https://www.bl.uk/learning/timeline/item106190.html. William Blake (1757—1827) was an artist, poet, mystic, visionary, and radical thinker. The densely-filled pages of this working notebook give a fascinating insight into his compositional process, allowing us to follow the genesis of some of his best-known work, including 'London', 'The Tyger,' and 'The Sick Rose'.

66 United States Holocaust Memorial Museum, "Children's Diaries during the Holocaust," in: *The Holocaust Encyclopedia*. Available online under:https://encyclopedia.ushmm.org/content/en/article/childrens-diaries-during-the-holocaust.

67 The memoirs of Ceija Stojka have been translated into six languages so far. *The Memoirs of Ceija Stojka, Child Survivor of the Romani Holocaust* appeared in November 2022 with Camden House, translated and edited by Lorely French.

68 "It is difficult to write about some things, but it has to be," was initially the title of the contribution of Lorely French and Carina Kurta for the workshop "Recording Roma Voices: Documenting Romani Lives" at the Central European University, Vienna, June 13—14, 2022. Available online under: https://events.ceu.edu/recording-romani-voices.

69 Translated from German into English by Simona Anozie, Stephanie Buhmann, Lorely French, Michaela Grobbel, and Carina Kurta.

70 The Buraku, also known as Burakumin, are an ethnic minority group in Japan. In earlier times they were isolated from the dominant peoples due to their religious beliefs or cultural customs and were forced to live in separate communities. The so-called "Liberation Policy" of 1871 was supposed to bring equal rights, but discrimination continued. In 1989, around the time when Ceija Stojka would have been visiting Japan, the Buraku Liberation League (BLL), founded in 1955, was playing a major role in the founding of the International Movement Against All Forms of Discrimination and Racism (IMADR).

71 According to Nuna Stojka, it is also possible that this interior was inspired by Ceija's Viennese apartment in the Kaiserstrasse, into which she moved in the 1980s. See the author's correspondence with Lorely French from July 6, 2023.

72 *The Red Studio* by Henri Matisse is part of the permanent collection of The Museum of Modern Art, New York.

73 Ceija Stojka, *The Memoirs of Ceija Stojka*, trans. by Lorely French, Rochester, N.Y.: Camden House, 2022, p. 66. Hereafter cited as *Memoirs* with the appropriate page number.

74 *Memoirs*, p. 145

75 Ibid., p. 162

76 Ibid., p. 69

*i Ceija Stojka, *Auschwitz est mon manteau et autres chants tsiganes*, trans. from the German by François Mathieu, Paris: Éditions Bruno Doucey, 2018, p. 36. Translated from the German into English by Simona Anozie, Stephanie Buhmann, Lorely French, Michaela Grobbel, and Carina Kurta.

*ii Ceija Stojka, *Auschwitz est mon manteau et autres chants tsiganes*. trans. from the German by François Mathieu, Paris: Éditions Bruno Doucey, 2018, p. 14. Translated from the German into English by Simona Anozie, Stephanie Buhmann, Lorely French, Michaela Grobbel, and Carina Kurta.

*iii Ceija Stojka, *Auschwitz est mon manteau et autres chants tsiganes*. trans. from the German by François Mathieu, Paris: Éditions Bruno Doucey, 2018, p. 16. Translated from the German in English by Simona Anozie, Stephanie Buhmann, Lorely French, Michaela Grobbel, and Carina Kurta.

*iv Ceija Stojka, *Auschwitz est mon manteau et autres chants tsiganes*, trans. from the German by François Mathieu, Paris: Éditions Bruno Doucey, 2018, p. 44. Translated from the German into English by Simona Anozie, Stephanie Buhmann, Lorely French, Michaela Grobbel, and Carina Kurta.

*v Ceija Stojka, *Auschwitz est mon manteau et autres chants tsiganes*. trans. from the German by François Mathieu, Paris: Éditions Bruno Doucey, 2018, p. 38. Translated from the German into English by Simona Anozie, Stephanie Buhmann, Lorely French, Michaela Grobbel, and Carina Kurta.

*vi Ceija Stojka, *Auschwitz est mon manteau et autres chants tsiganes*. trans. from the German by François Mathieu, Paris: Éditions Bruno Doucey, 2018, pp. 114—6. Translated from German into English by Simona Anozie, Stephanie Buhmann, Lorely French, Michaela Grobbel, and Carina Kurta.

LIST OF ILLUSTRATIONS

Fig. 1: Ceija Stojka, *Untitled*, 2006, Acrylic on canvas, 19 ½ × 27 ½ in. (49.5 × 70 cm), Photo: Rebecca Fanuele. Courtesy of Galerie Christophe Gaillard, Paris.

Fig. 2: Ceija Stojka, *Mama, the Water is Freezing. 1943 Auschwitz*, 2005, Ink on paper, 12 ½ × 9 ½ in. (32 × 24 cm), Photo: Rebecca Fanuele. Courtesy of Galerie Christophe Gaillard, Paris.

Fig. 3: Ceija Stojka, *I Love You*, 1995, Acrylic on canvas, 27 ½ × 39 ⅓ in. (100 × 70 cm), Photo: Bill Carrigan. Courtesy of Stackpole & French Law Offices, Stowe, Vermont.

Fig. 4: Ceija Stojka, *Untitled*, 2007, Oil on canvas, 25 ½ × 15 ½ in. (64.8 × 39.4 cm), Photo: Corey Caswell. Courtesy of Private Collection, USA.

Fig. 5: Ceija Stojka, *Sidi, My Mother*, 1996, Acrylic on paper, 27 ½ × 39 ⅓ in. (70 × 100 cm), Photo: Bill Carrigan. Courtesy of Galerie Christophe Gaillard, Paris.

Fig. 6: Ceija Stojka, *They are Happy with What They Have, That is Freedom*, 1995, Acrylic on canvas, 27 ½ × 39 ⅓ in. (70 × 100 cm), Photo: Kevin Noble. Courtesy of Galerie Christophe Gaillard, Paris.

Fig. 7: Ceija Stojka, *Untitled*, 1993, Acrylic on canvas, 19 ¾ × 25 ⅝ in. (50 × 65 cm), Photo: Rebecca Fanuele. Courtesy of Galerie Christophe Gaillard, Paris.

Fig. 8: Ceija Stojka, *Mama*, 1995, Acrylic on canvas, 27 ½ × 39 ⅓ × in. (70 × 100 cm), Photo: Bill Carrigan. Courtesy of Pacific University, Forest Grove, Oregon.

Fig. 9: Ceija Stojka, *I'll Never be Someone Else*, 1995, Acrylic on canvas, 27 ½ × 39 ⅓ in. (69.8 × 100 cm), Photograph by Rebecca Fanuele. Courtesy of Galerie Christophe Gaillard, Paris.

Fig. 10: Ceija Stojka, *Untitled*, 1993, Gouache on cardboard, 19 ½ × 25 ½ in. (50 × 65 cm), Photo: Kevin Noble. Courtesy of Galerie Christophe Gaillard, Paris.

Fig. 11: Ceija Stojka, *Untitled*, 1993, Gouache on cardboard, 19 ⅔ × 25 ½ in. (50 × 65 cm), Photo: Kevin Noble. Courtesy of Galerie Christophe Gaillard, Paris.

Fig. 12: Ceija Stojka, *The Final Solution, August 1, 1944, Began up Front by the Canteen of the SS*, 2005, Ink on paper, 9 ⅓ × 12 ½ in. (24 × 32 cm), Photo: Kevin Noble. Courtesy of Estate Family Stojka, Vienna.

Fig. 13: Ceija Stojka, *Untitled (Mamo, my Child)*, 2003, Ink on paper, 11 ½ × 16 ½ in. (29.5 × 42 cm), Photo: Kevin Noble. Courtesy of Estate Family Stojka, Vienna.

Fig. 14: Ceija Stojka, *Ravensbrück, Auschwitz, Bergen-Belsen*, 1995, Acrylic on cardboard, 32 ½ × 43 ⅔ in. (82.5 × 111 cm), Photo: Rebecca Fanuele. Courtesy of Galerie Christophe Gaillard, Paris.

Fig. 15: Ceija Stojka, *Plock 10 (Block 10), 1943 Auschwitz*, 2011, Ink on paper, 11 ½ × 16 ½ in. (29.5 × 42 cm), Photo: Matthias Reichelt. Courtesy of Estate Family Stojka, Vienna.

Fig. 16: Ceija Stojka, *The Ambassadors of God, Auschwitz 1943*, 2004, Ink on paper, 10 ⅓ × 14 ½ in. (26 × 37 cm), Photograph by Kevin Noble. Courtesy of Galerie Christophe Gaillard, Paris.

Fig. 17: Ceija Stojka, *They Devoured Us*, 1995, Watercolor on paper, 11 ¾ × 8 ¼ in. (30 × 21 cm), Photo: Bill Carrigan. Courtesy of Private Collection, USA.

Fig. 18: Ceija Stojka, *Untitled*, 2001, Acrylic on cardboard, 19 ⅔ × 13 ⅔ in. (50 × 35 cm), Photo: Rebecca Fanuele. Courtesy of Galerie Christophe Gaillard, Paris.

Fig. 19: Ceija Stojka, *The Beautiful Women of Auschwitz*, 1997, Acrylic on canvas, 39 ⅓ × 27 ½ in. (100 × 70 cm), Photo: Rebecca Fanuele. Courtesy of Galerie Christophe Gaillard, Paris.

Fig. 20: Ceija Stojka, *Mama, Where is the Mother of the Child (Auschwitz)*, 2009, Ink on paper, 11 ⅓ × 16 ½ in. (29 × 42 cm), Photo: Rebecca Fanuele. Courtesy of Galerie Christophe Gaillard, Paris.

Fig. 21: Ceija Stojka, *Notebook, Book Cover, 1993*, Photo: Célia Pernot. Courtesy of the Ceija Stojka International Association.

Fig. 22: Ceija Stojka, *Notebook, The Origins of My Pictures, 1995*, Photo: Célia Pernot. Courtesy of the Ceija Stojka International Association.

Fig. 23: *Ceija Stojka during her trip to Japan*, December 1989, Photo: Taichiro Kajimura. Courtesy of the Ceija Stojka International Association.

Fig. 24: Ceija Stojka, *Notebook, Wurdon/wagon, 1993*, Photo: Célia Pernot. Courtesy of the Ceija Stojka International Association.

Fig. 25: Ceija Stojka, *Untitled (Bergen-Belsen)*, 1995, Ink on paper, 27 ½ × 39 ⅓ in. (70 × 100 cm), Photo: Rebecca Fanuele. Courtesy of Galerie Christophe Gaillard, Paris.

Fig. 26: Ceija Stojka, *Untitled*, 1993, Gouache on cardboard, 19 ⅔ × 25 ½ in. (50 × 65 cm), Photo: Rebecca Fanuele. Courtesy of Galerie Christophe Gaillard, Paris.

Fig. 27: Ceija Stojka, *Untitled*, 1991, Gouache on cardboard, 19 ½ × 25 ½ in. (50 × 65 cm), Photo: Kevin Noble. Courtesy of Galerie Christophe Gaillard, Paris.

Fig. 28: Anna Mary Robertson "Grandma" Moses, *The Old Checkered House*, 1944, Oil on pressed wood, Image courtesy Kallir Research Institute, New York. © Grandma Moses Properties Co., New York.

Fig. 29: Doris Zinkeisen, *Belsen: April 1945*, 1945, Oil on canvas, 24 ½ × 27 ½ in. (62.2 × 70 cm), Copyright Imperial War Museum (Art.IWM ART LD 5467).

Fig. 30: Ceija Stojka, *Mama, Why are You Dead? Bergen-Belsen, 1945*, 2005, Ink on paper, 9 ½ × 12 ½ in. (24 × 32 cm), Photo: Kevin Noble. Courtesy of Estate Family Stojka, Vienna.

Fig. 31: Ceija Stojka, *Bergen-Belsen, 1945*, 1996, Mixed media on cardboard, 19 ⅔ × 25 ⅔ in. (50 × 65.5 cm), Photo: Kevin Noble. Courtesy of Galerie Christophe Gaillard, Paris.

Fig. 32: Ceija Stojka, *Birkenau*, 1944, 2007, Acrylic on canvas, 15 ⅔ × 23 ½ in. (40 × 60 cm), Photo: Rebecca Fanuele. Courtesy of Galerie Christophe Gaillard, Paris.

Fig. 33: Käthe Kollwitz, *Death and Woman Fighting for the Child*, 1911, Etching, Image courtesy of Kallir Research Institute, New York. © 2023 Artists Rights Society (ARS), New York.

Fig. 34: Ceija Stojka, *Off to the KZ!*, 1995, Ink on paper, 11 ½ × 8 ¼ in. (29.5 × 21 cm), Photo: Kevin Noble. Courtesy of Estate Family Stojka, Vienna.

Fig. 35: Malgorzata Mirga-Tas, *May*, from the series *Re-enchanting the World*, 2022, Textile, acrylic, wooden stretcher, 182 × 213 in. (462.3 × 541 cm), Photo: Jacopo Salvi. Courtesy of the artist and Foksal Gallery Foundation.

Figs. 36-41: Austrian Cultural Forum New York, *What Should I Be Afraid of? Roma Artist Ceija Stojka*, May 23-September 25, 2023, Installation views, Photos: Kevin Noble. Courtesy of the Austrian Cultural Forum New York.

Fig. 42: Ceija Stojka, *Yes My Führer*, 2005, Acrylic on canvas, 15 ⅔ × 11 ⅔ in. (40 × 29.8 cm), Photo: Rebecca Fanuele. Courtesy of Galerie Christophe Gaillard, Paris.

Fig. 43: Ceija Stojka, *Untitled (Ravensbrück)*, 2001, Acrylic on cardboard, 39 ½ × 27 ½ in. (100 × 70 cm), Photo: Rebecca Fanuele. Courtesy of Galerie Christophe Gaillard, Paris.

CHRONOLOGY

15 January 1933 At the invitation of the provincial government of Burgenland, the mayors, councilors, and members of parliament for South Burgenland met to discuss the "Gypsy Question." One proposal called for their deportation to an island in the Pacific.

23 May 1933 Ceija Stojka was born in an inn in Kraubath an der Mur, Styria. She was named Margarethe Rigo Stojka and was the fifth of six children. Her father Wackar Horvath and mother Sidonie "Sidi" Rigo Stojka were itinerant Lovara Roma from Graz and Burgenland respectively.

1935 The Nuremberg Race Laws in Nazi Germany placed the Roma and Sinti as people with "foreign blood" on the same level as the Jews.

1936 The Christian Socialist Fascist corporate state ["Ständestaat"] set up a "Central Office to Combat the Gypsy Nuisance" in Vienna.

1937 The illegal NSDAP (National Socialist Party) in Burgenland issued the slogan "Burgenland free of Gypsies."

March 1938 "Annexation" of Austria by Nazi Germany. Tobias Portschy, the Nazi provincial governor of Burgenland, published a racist leaflet on the "Gypsy Question." In May of that year Roma children were banned from attending school. On 5 June the first orders were issued to detain Roma from Burgenland in Dachau and Buchenwald.

17 October 1939 Ceija Stojka and her family were traveling in Styria when they learned that a decree had been passed forbidding all Roma to leave their place of abode. They decided to move to Vienna where their father rebuilt their wagon into a small hut on a friend's property.

23 November 1940 The "Lackenbach Forced Labor Camp for Gypsy Families" was set up. For most of the Roma and Sinti interned there, Lackenbach was a transit camp on the way to extermination.

1941 Stojka's father was arrested and sent to Dachau. It was not until 2003 that she learned that her father had been deported in 1942 from Dachau, then to Neuengamme, then to Sachsenhausen, then back to Dachau, and finally to Hartheim in Upper Austria, where he was a victim of the T4 euthanasia program.

16 December 1942 The "Auschwitz Decree" called for the deportation of all "Gypsies" to the Auschwitz-Birkenau concentration and extermination camp.

March 1943 The entire Stojka family was deported to Auschwitz. Ceija Stojka had the number Z 6399 tattooed on her left arm. The same year, about 5,000 Austrian Roma and Sinti were deported to Łódź and subsequently exterminated in Chełmo.

1943 Stojka's youngest brother Ossi, aged seven, contracted typhoid fever and died in Auschwitz.

July 1944 Later that month all remaining inmates of the Auschwitz-Birkenau "Gypsy Camp" who were still able to work were transferred to other concentration camps.

August 1944 Ceija Stojka, her mother Sidi, her sister Kathi, and an aunt were transferred to Ravensbrück women's camp. During the night of 2 August all Sinti and Roma remaining in Auschwitz were gassed. It is estimated that over 4,000 Sinti and Roma were murdered.

January 1945 Ceija was transferred to Bergen-Belsen in Lower Saxony.

15 April 1945 British troops liberated the camp of Bergen-Belsen. Of Stojka's immediate family—over 200 persons—her mother, Ceija, two brothers, and two sisters survived. Most of her extended family perished. Of the some 11,000 Austrian Roma and Sinti, only about 2,000 survived the Holocaust. Ceija Stojka and other survivors returned to Austria. After a short stay in Vienna, they went back to their itinerant lives.

20 September 1948 The Ministry of the Interior headed by Oskar Helmer issued a decree on the "Gypsy Nuisance," ordering the expulsion of stateless Roma.

1949–1955 Ceija Stojka bore three children: Hojda, Silvia, and Jano. During this time the family's situation changed radically. Stojka acquired a trade license to sell carpets at markets throughout Austria. Stojka also sold fabrics door-to-door in Vienna.

1961 The Austrian Roma and Sinti were granted reparations as a result of the pressure of victim associations.

1988 Stojka's book *Wir leben im Verborgenen: Erinnerungen einer Rom-Zigeunerin* [*We Live in Secrecy: Memories of a Romni*] was the first work written by an Austrian Romni describing the fate and suffering of the Roma in concentration and extermination camps. It acted as a stimulus for the establishment of a Roma movement in Austria. In the following years, numerous exhibitions and shows in Austria and Germany presented the traditional art and culture of the Roma people. In the late 1980s, Stojka and the late singer Ruza Nikolic-Lakatos began to present the songs of the Lovara Roma.

1989 In order to come to terms with her past but also to express her zest for life, Stojka began to paint in the late 1980s. As a self-taught artist, she produced astonishing works that were shown in numerous exhibitions in Austria and other countries. The first Roma association in Austria was founded in Oberwart.

1991 The "Romano Centro" and the "Cultural Association of the Austrian Roma in Vienna" were founded.

4–29 March 1991 Ceija Stojka's works were exhibited at the Cultural Center Amerlinghaus, Vienna, Austria. Curator: Christa Stippinger. Further exhibitions were to follow almost annually for many years.

1992 Stojka published her second book *Reisende auf dieser Welt* [*Travellers in This World*], describing her life after the war.

24 December 1993 The Roma were recognized as an official ethnic group by the Austrian government.

1994 The Minority Education Act in Burgenland permitted teaching in the Romani language.

4 February 1995 Four members of the Roma community from Oberwart in the province of Burgenland were targeted and killed in a bomb attack.

2000 The right-wing extremist Freedom Party of Austria (FPÖ) formed a coalition government with the conservative Austrian People's Party (ÖVP).

2000 Stojka's CD, *Me Dikhlem Suno* [*I Had A Dream*], on which she sings in Romany, was produced.

2003 The collection of poems *Meine Wahl zu schreiben—ich kann es nicht / O fallo de isgiri—me tschischanaf les* [*My Choice to Write—I Cannot Write*] was published.

2003 *Unter den Brettern hellgrünes Gras/ The green green grass beneath*, the documentary about Ceija Stojka by Karin Berger was released.

2005 *Ceija Stojka. Leben!* Exhibit at the Jüdisches Museum Wien; Curator: Gerhard Milchram.

2005 Stojka's book *Träume ich, dass ich lebe?: Befreit aus Bergen-Belsen, [Am I Dreaming I'm Alive? Freed from Bergen-Belsen]* was published.

2009–2010 Monograph exhibition *LIVE—DANCE—PAINT* appeared at the Cawein Gallery, Pacific University; Sonoma State University Library Art Gallery, Rohnert Park, California; West Branch Gallery, Stowe Vermont, USA. Curators: Lorely French and Michaela Grobbel.

28 January 2013 Ceija Stojka died.

2014 Monograph Exhibition, *Ceija Stojka, Sogar der Tod hat Angst vor Auschwitz [Even Death Is Terrified of Auschwitz, Vi o merino oral katar o Auschwitz]*, Kunstverein Tiergarten, Berlin; Galerie Schwartzsche Villa, Kulturamt Steglitz-Zehlendorf, Berlin; Mahn und Gedenkstätte Ravensbrück, Fürstenberg/Havel. Curators: Matthias Reichelt and Lith Bahlmann.

2015 Monograph Exhibition, *Wir leben im Verborgenen / We Live in Secrecy*, Heidelberger Kunstverein, based on the exhibition of Matthias Reichelt and Lith Bahlmann.

2014 A new square on Lerchenfelder Strasse in Vienna was named "Ceija-Stojka-Platz."

2017 ERIAC, The European Roma Institute for Arts and Culture, the transnational, European-level organization for the recognition of Roma arts and culture, was launched.

2018 Monograph exhibition, *Ceija Stojka, une artiste Rom dans le siècle*, Maison Rouge, Paris. Curators: Antoine de Galbert and Xavier Marchand.

2018 Theatrical readings of *Je rêve que je vis, libérée de Bergen Belsen,* Maison de la Poésie, at the Mémorial de la Shoah and at Le Musée de national de l'histoire de l'immigration, Paris, were staged. Directed by Xavier Marchand, with actress Camille Grandville.

2018 The Ceija Stojka International Fund/Association was created to contribute to the knowledge and international influence of the work of Ceija Stojka (1933—2013). The Fund was transformed into the Ceija Stojka International Association in 2023, and moved to Austria.

2019 Lecture and discussion with Nuna Stojka and Ceija Stojka's son Hojda Stojka about the history of Roma and Sinti during the NS regime at Schloss Hartheim/Upper Austria, where Hojda's grandfather, Wackar Horvath, was killed.

2019 Monograph exhibition, *Ceija Stojka—War memories of a Roma,* Het Valkhof Museum, Nijmegen, the Netherlands; Curators: Paula Aisemberg, Noëlig Le Roux, and Xavier Marchand.

2019 Monograph exhibition, *Ceija Stojka (1933—2013), Museo Nacional Centro de Arte Reina Sofía,* Madrid, Spain; Curators: Paula Aisemberg, Noëlig Le Roux, and Xavier Marchand.

2021 Monograph exhibition, *Ceija Stojka (1933—2013),* Konsthall Malmö, Malmö,Sweden. Curators: Noëlig Le Roux, and Xavier Marchand.

2022 Documenta 15 Kassel, Germany, group exhibition *One Day We Shall Celebrate Again: RomaMoMA, the central artistic and cultural initiatives of ERIAC, at art fair documenta fifteen.* Curators: Daniel Baker, Ethel Brooks, Tímea Junghaus, Hajnalka Somogyi, Eszter Szakács, Katalin Székely, and Miguel Ángel Vargas.

2022 Manifesta Prishtina, collective exhibition „ALL THAT WE HAVE IN COMMON," November 2022—March 2023, Museum of Contemporary Art,Skopje, Macedonia. Curators: Mira Gakina and Jovanka Popova.

8 April 2023 On International Romani Day, The Istituto Cultura Gitana Award for Fine Art was posthumously awarded to Ceija Stojka, presented to Hojda and Nuna Stojka.

23 May—25 September, 2023 Monograph exhibition *What Should I be Afraid of? Roma Artist Ceija Stojka,* Austrian Cultural Forum New York, USA. The exhibition opens on what would have been Ceija Stojka's 90th birthday. Curators: Stephanie Buhmann, Lorely French, and Carina Kurta.

BIBLIOGRAPHY

"A Day in the Life: Artists' Diaries from the Archives of American Art," Exhibition from September 26, 2014—February 28, 2015. Available online under: https://www.si.edu/exhibitions/day-life-artists-diaries-archives-american-art%3Aevent-exhib-5576

Bauer, Sidonia. "Arguments on the Empowerment of Sinti*ezze and Rom*nja Through the Resource of Social Space in Traveling Communities," in: *Approaches to a "new" World Literature. Romani Literature(s) as (Re-)Writing and Self-Empowerment,* Lorely French and Marina Ortrud Hertrampf, eds. Munich: AVM, forthcoming 2024.

Bauer, Sidonia. "Écrivaines samudaripiennes: les Lager de Stojka et Franz," in: Marina O. Hertrampf and Kirsten Hagen, eds., *Romani Aesthetic(s)—self-and external representations.* Munich: AVM edition, 2020, pp. 205—236.

Baumgartner, Gerhard. "Der Genozid an den österreichischen Roma und Sinti," in: *Romane Thana: Orte der Roma und Sinti,* Andrea Härle, Cornelia Kogoj, Werner Michael Schwarz, Michael Weese, and Susanne Winkler, eds. Vienna: Wien Museum, Landesmuseum Burgenland, Initiative Minderheiten, Romano Centro, and Czernin Verlag, 2015, pp. 86—93.

Baumgartner, Gerhard. "Roma and Sinti in Austria." in: idem, *Gypsy Camp Lackenbach. List of Identified Victims 13.11.2010. In Commemoration of the 70th Anniversary of the Establishing of 'Gypsy Camp Lackenbach' on the 23rd of November 1940.* Vienna: KANZLEI, 2010.

Baumgartner, Gerhard. "Sinti und Roma in Österreich," *pogrom* 130 no. 6, 1987.

Blake, William. "William Blake's Notebook 1794." British Library Learning Timelines: Sources from History. Available online under: https://www.bl.uk/learning/timeline/item106190.html.

Ceija Stojka (1933—2013): Sogar der Tod hat Angst vor Auschwitz/Even Death is Terrified of Auschwitz/Vi O Merimo Daral Katar O Auschwitz, Lith Bahlmann and Matthias Reichelt, eds. Nuremberg: Verlag für moderne Kunst, 2014.

Danckwortt, Barbara. "The ground beneath our feet was very hot and black: human dust.'Auschwitz, Ravensbrück, Bergen-Belsen," in: *Ceija Stojka (1933—2013): Sogar der Tod hat Angst vor Auschwitz/Even Death is Terrified of Auschwitz/Vi O Merimo Daral Katar O Auschwitz.* Nuremberg: Verlag für Moderne Kunst, 2014, pp. 416—24.

Fings, Karola. "Die Anzahl der Opfer." RomArchive. 2019. Available online under: https://www.romarchive.eu/de/voices-of-the-victims/the-number-of-victims/.

Franz, Philomena. *Zwischen Liebe und Haß: Ein Zigeunerleben.* 1st edition 1985. Freiburg, Basel, Vienna: Herder, 1992.

French, Lorely. "How to Cook a Hedgehog: Ceija Stojka and

Romani Cultural Identity Through the Culinary Arts," in: *Cuisine and Symbolic Capital: Food in Film and Literature*. Cheleen Ann-Catherine Mahar, ed. Newcastle upon Tyne: Cambridge Scholars Publishing, 2010, pp. 104—129.

Grobbel, Michaela. "Contemporary Romany Autobiography as Performance," in: *German Quarterly*, 76.2 (2003), pp. 140—154.

Grobbel, Michaela. "Crossing Borders of Different Kinds: Roma Theater in Vienna," in: *The Journal of Austrian Studies*, 48.1 (2015), pp. 1—26.

Halwachs, Dieter W. "Romani in Österreich," in: Dieter W. Halwachs and Florian Menz, eds. *Die Sprache der Roma: Perspektiven der Romani-Forschung in Österreich im interdisziplinären und internationalen Kontext*. Klagenfurt: Drava Verlag, 1999, pp. 112—46.

Hancock, Ian. "'Uniqueness' of the Victims: Gypsies, Jews and the Holocaust," in: *Without Prejudice: The EAFORD International Review of Racial Discrimination* 1.2 (1988), pp. 45—67.

Kubica, Helena and Piotr Setkiewicz." The Last Stage of the Functioning of the *Zigeunerlager* in the Birkenau Camp (May—August 1944)." *Memoria: Memory, History, Education* 10 (July 2018): pp. 6—15. https://view.joomag.com/ memoria-en-no-10-july-2018/ 0531301001532506629.

Lewy, Guenter. *The Nazi Persecution of the Gypsies*. New York: Oxford UP, 2000.

Memorial and Museum Auschwitz-Birkenau. "News: Sixty-First Anniversary of the Liquidation of the Gypsy Camp in Birkenau," August 8, 2005. Available online under: https://www.auschwitz.org/ en/museum/news/ sixty-first-anniversary-of-the-liquidation-of-the-gypsy-camp-in-birkenau,427.html and https:// www.auschwitz.org/en/history/ categories-of-prisoners/sinti-and-roma-gypsies-in-auschwitz/).

Museo Dolores Olmedo. "A Peek at Frida Kahlo's Diary." Google Arts and Culture. Available online under: https:// artsandculture. google.com/story/a-peek-at-frida-kahlo-s-diary-museo-dolores-olmedo/AWxmDksayhmJA?hl=en .

Pankok, Moritz, ed. *Ort des Sehens/Kai Dikhas/Place to See 2: Damian Le Bas, Gabi Jiménez, Imrich Tomáš, Ceija Stojka, Kiba Lumberg, Nihad Nino Pušija*. Berlin: Edition Braus/ Galerie Kai Dikhas, 2012.

Peritore, Silvio and Frank Reuter. "Der Nationalsozialistische Völkermord an den Sinti und Roma: Ein Überblick," in: *O Kalo Phani/Das schwarze Wasser: Das Denkmal für die im Nationalsozialismus ermordeten Sinti und Roma Europas*. Berlin: Edition Braus, 2012.

Rose, Romani (ed.). *The Nazi Genocide of the Sinti and Roma*. 2nd rev. ed. Heidelberg: Documentary and Cultural Centre of German Sinti and Roma, 1995.

Sakowska, Ruta. *Die zweite Etappe ist der Tod: NS-Ausrottungspolitik gegen die polnischen Juden, gesehen mit den Augen der Opfer*. Berlin: Edition Hentrich, 1993.

Smith, Fergus. *Romany-English Glossary*, March 1998. Available online under: http://www2.arnes. si/~eusmith/Romany/glossary.html.

Solomon, Deborah. "Van Gogh and the Consolation of Trees," New York Times, May 11, 2023; updated May 14, 2023. Available online under: https://www.nytimes.com/2023/ 05/11/arts/design/van-gogh-cypresses-met-museum.html.

State Museum Auschwitz-Birkenau. *The Memorial Book: The Gypsies at Auschwitz-Birkenau XIV*. Munich: K.G. Saur, 1993.

Stojka, Ceija. *Me Dikhlem Suno*. CD. Vienna: non food factory and Navigator Film, 2000.

Stojka, Ceija. *Meine Wahl zu schreiben—ich kann es nicht: Gedichte (Romanes, deutsch) und Bilder*. Landeck: EYE: Literatur der Wenigerheiten, 2003.

Stojka, Ceija. *The Memoirs of Ceija Stojka*. Trans. by Lorely French. Rochester, N.Y.: Camden House, 2022.

Stojka, Ceija. "Sie waren vom Stamm der Lovara" in: *auschwitz ist mein mantel: bilder und texte*. Vienna: edition exil, 2008.

Stojka, Ceija. "So kochten die Romnja/Kadej kiravenas e Romna." In: *Fern von uns im Traum. Märchen, Erzählungen und Lieder der Lovara/Te na dikhas sudende … Lovarenge paramiči, tertenetura taj gjila*. Petra Cech, Christiane Fen.nisz-Juhasz, Dieter W. Halwachs, and F. Heinschink Mozes, eds. Klagenfurt: Drava, 2001, pp. 280—89.

Stojka, Ceija. *Reisende auf dieser Welt: Aus dem Leben einer Rom-Zigeunerin*. Vienna: Picus, 1992.

Stojka, Ceija. *Träume ich, dass ich lebe? Befreit aus Bergen-Belsen*. Vienna: Picus, 2005.

Stojka, Ceija. *Wir leben im Verborgenen: Erinnerungen einer Rom-Zigeunerin*. Vienna: Picus, 1988.

Stojka, Ceija. *Wir leben im Verborgenen. Aufzeichnungen einer Romni zwischen den Welten*. Ed. with an essay by Karin Berger. Vienna: Picus Verlag, 2013.

Stojka, Ceija and Karin Berger. "'You mustn't be anyone else': Interview with Ceija Stojka," in: Ceija Stojka, *The Memoirs of Ceija Stojka*. Trans. by Lorely French. Rochester, N.Y.: Camden House, 2022, pp. 175—208.

Stojka, Mongo. *Papierene Kinder: Glück, Zerstörung und Neubeginn einer Roma-Familie in Österreich*. Vienna: Molden, 2000. United States Holocaust Memorial Museum. "Children's Diaries during the Holocaust." *Holocaust Encyclopedia*. Available online under: https://encyclopedia.ushmm.org/content/en/article/childrens-diaries-during-the-holocaust

Tyrnauer, Gabrielle. "'Mastering the Past': Germans and Gypsies," in: *Gypsies: An Interdiscipinary Reader*. Diane Tong, ed. New York and London: Routledge, 1998, pp. 97—114.

United States Holocaust Memorial Museum. "Children's Diaries during the Holocaust," in: *Holocaust Encyclopedia*. Available online under: https://encyclopedia. HYPERLINK "http://ushmm.org/content/en/article/" ushmm.org/content/en/article/childrens-diaries-during-theholocaust.

Van Gogh, Vincent. *The Letters*. ed. Leo Jansen, Hans Luijten, and Nienke Bakker. Amsterdam: Van Gogh Museum; The Hague: Huygens Instituut KNAW. October 2021. Available online under: https://vangoghletters.org/.

Ward-Jackson, C. H. and Denis E. Harvey with drawings by Denis E. Harvey. *The English Gypsy Caravan: Its Origins, Builders, Technology and Conservation*. Newton/Abbot: David & Charles, 1972.

CONTRIBUTORS

Simona Anozie is the granddaughter of Ceija Stojka and played a major role in the artist's life. She is mentioned often in Stojka's writings as being an inspiration for creativity and art. Anozie lives with her brother, Pablo Stojka, Ceija Stojka's grandson, and her family in Vienna. Together with Pablo Stojka, she represents the next generation of Roma whom Ceija Stojka wanted to educate about the beauty of Romani cultures and the horrors of their past under National Socialism.

Stephanie Buhmann, PhD, Head of Visual Arts, Architecture & Design at the Austrian Cultural Forum New York. She has written extensively on visual art and her essays have appeared in a variety of books, international art magazines, and newspapers. Besides curating dozens of exhibitions, she has conducted over ninety published interviews with contemporary artists. In 2013 she conceived of an ongoing book series titled *Studio Conversations*, which focuses on women of different generations working in diverse media. Her latest monograph *Frederick Kiesler: Galaxies* was published in 2023 by The Green Box, Berlin.

Lorely French, PhD, Professor of German at Pacific University, Oregon. Her publications on Ceija Stojka and Romani Literatures include *Roma Voices in the German-speaking World* (Bloomsbury 2015/2016), essays on Stojka and Austrian Roma for the online digital archive RomArchive, co-editorship of a special issue on Romani Literatures for *Romani Studies* (2020), and co-editorship and an essay on Stojka in a forthcoming volume on Romani Literatures as World Literature to appear with AVM publishers in 2023. Her annotated English-language translation of Ceija Stojka's memoirs appeared in 2022 with Camden House. She is a board member of the Ceija Stojka International Association and the Gypsy Lore Society.

Michaela Grobbel, PhD, Professor of German at Sonoma State University in California. In her book *Enacting Past and Present: The Memory Theaters of Djuna Barnes, Ingeborg Bachmann, and Marguerite Duras* (2009), she develops her theory of a "feminist art of memory," which shows her interest in the relationship of memory and performance in women's autobiographical literature. She has extended this research into cultural studies, particularly ethnic minority studies, focusing on self-representation through literature, art, and theater by Roma in German-speaking countries. She has published articles and book chapters about Romani autobiography and representations of Roma in literature and theater. Together with Dr. Lorely French, Grobbel organized the first public touring art exhibits of Stojka's works in the USA "LIVE-DANCE-PAINT: Works by Romani ('Gypsy') Artist Ceija Stojka" in 2009/2010.
Susanne Keppler-Schlesinger, PhD, Director of the Austrian Cultural Forum New York since September 2022. She is an Austrian career diplomat. Before starting her position at the ACFNY, she was Deputy Director of the Diplomatische Akademie Wien / Vienna School of International Studies and Head of its Executive Training Department, as well as Director of the Austrian Cultural Forum in Paris. She served at the Permanent Mission of Austria to the United Nations in New York, where she focused inter alia on the protection of human rights and gender equality.
Carina Kurta, MA, Coordinator of the Ceija Stojka International Association, Coordinator of the Ceija Stojka International Association. She is an art historian and museologist, who has accompanied the Stojka family for several years. As a link between researchers, curators, and museums, Kurta has assisted in organizing exhibitions and events focused on Stojka's art since 2015. From 2018 to 2020, supported by a grant from the Future Fond of the Republic of Austria and the Antoine de Galbert Foundation, Kurta carried out a preservation project on Stojka's handwritten work, her notebooks, and diaries.

IMPRINT

This book is published on the occasion of the exhibition
What Should I Be Afraid of?
Roma Artist Ceija Stojka
May 23—September 25, 2023

Curators: Stephanie Buhmann, Lorely French, Carina Kurta

Austrian Cultural Forum New York
11 East 52nd Street
New York, NY 10022
www.acfny.org

Director ACFNY:
Susanne Keppler-Schlesinger
Deputy Director:
Melina Tsiamos
Head of Visual Arts, Architecture and Design:
Stephanie Buhmann
Head of Music, Film & Performance:
Kinga Salti
Head of Communications:
Valentina Funes-Rainer

Published by:
Hirmer Verlag GmbH
Bayerstrasse 57-59
80335 Munich
Germany
www.hirmerpublishers.com

Senior Editor Hirmer Publishers:
Elisabeth Rochau-Shalem
Project Manager Hirmer Publishers:
Rainer Arnold

Copy editing and proof reading:
Jane Michael

Layout and typesetting:
Sophie Friederich

Pre-press:
Reproline Mediateam, Munich

Printing:
Grafisches Centrum Cuno, Calbe

Printed in Germany

The Deutsche Nationalbibliothek lists this publication in the Deutsche Nationalbibliografie; detailed bibliographic data is available on the Internet at http://www.dnb.de.

Texts: © the Authors
Translation: © Lorely E. French and as indicated in the relevant footnotes
© 2023 Hirmer Publishers, Munich; Austrian Cultural Forum New York.

ISBN 978-3-7774-4272-3

Kontakt Collection is an independent non-profit association based in Viena. Its purpose is the support and promotion of Central, Eastern, and Southeastern European Art.
www.kontakt-collection.org

FSC MIX Paper | Supporting responsible forestry
www.fsc.org FSC® C015829